VOYAGER 3

David Martin Darst

VOYAGER 3

Fifty Four Phases of Feeling

SEAPOINT BOOKS

ONE GOVERNMENT STREET
KITTERY, ME 03904
TEL: 207.703.2314 / BIZBOOKS2@AOL.COM / WWW.SMITHKERR.COM

Seapoint Books

One Government Street, Kittery, ME 03904

www.smithkerr.com

Design by Elizabeth DiPalma Design

Printed in China through Printworks Int. Ltd.

ISBN: 978-0-9830622-2-6

Dedication

To the onlie begetter of
this ensuing [book]
Mr. Wm. Shakespeare all happinesse
and that eternitie
promised
by
our ever-living poet
wisheth
the well-wishing
adventurer in
setting
forth.[1]

– D.M.D.

But a merrier man,

Within the limit of becoming mirth,

I never spent an hour's talk withal.

His eye begets occasion for his wit;

For every object that the one doth catch

The other turns to a mirth-moving jest,

Which his fair tongue, conceit's expositor,

Delivers in such apt and gracious words,

That aged ears play truant at his tales,

And younger hearings are quite ravished;

So sweet and voluble is his discourse.[2]

[1] Based on the original dedication of Shakespeare's sonnets.

[2] William Shakespeare, *Love's Labour's Lost,* Act II, scene i, ll.66-76.
The description is thought to be a self-portrait.

Launched aboard Titan IIIE/
Centaur rockets were:
Voyager 1, on September 5, 1977; and
Voyager 2, on August 20, 1977.

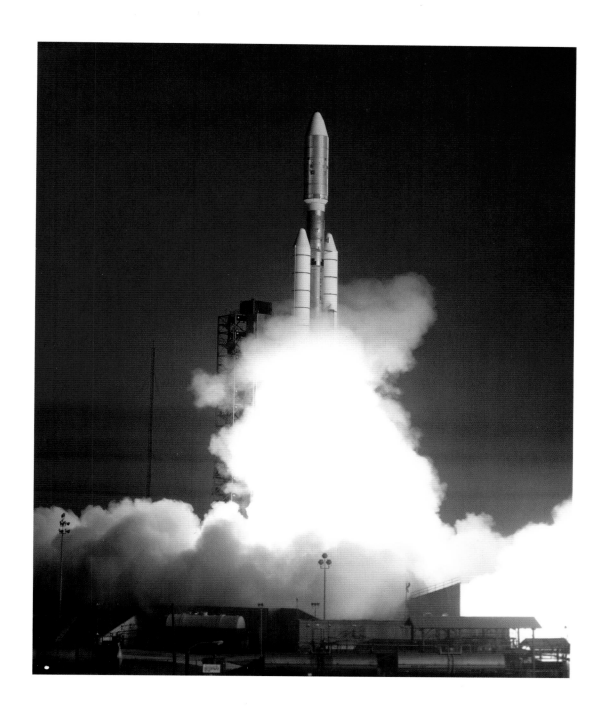

BOTH VEHICLES USED THE
GRAVITY SLINGSHOT OF JUPITER,
SATURN, URANUS, AND NEPTUNE
TO ENTER DEEP SPACE.

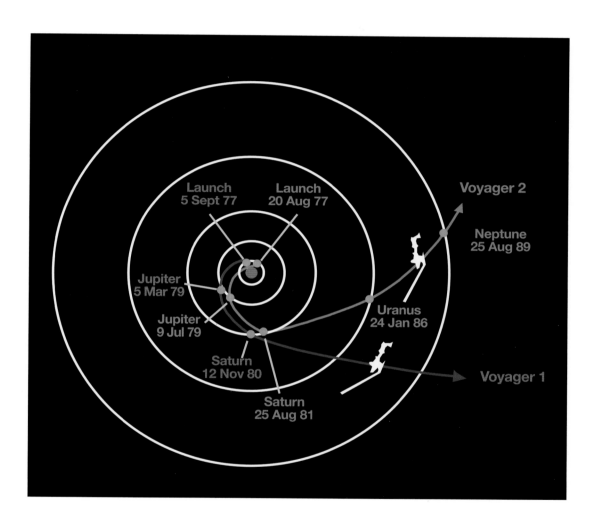

Voyager 1 AND *Voyager 2*
ARE PASSING THROUGH
THE LAST VESTIGES OF THE SOLAR WIND,
EXITING THE HELIOSHEATH
AND CROSSING THE HELIOPAUSE,
INTO INTERSTELLAR SPACE.

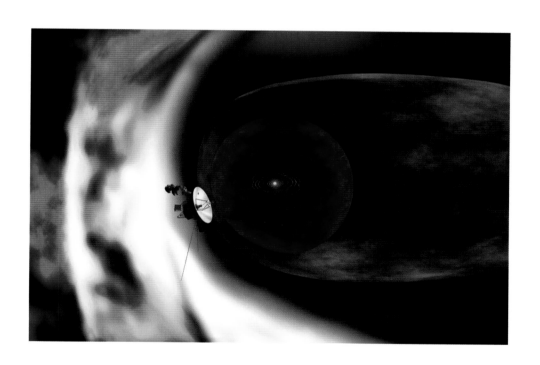

THEY ARE MORE THAN
ELEVEN BILLION MILES FROM THE SUN,
TRAVELING AT THIRTY-EIGHT THOUSAND MILES
PER HOUR AND SENDING SIGNALS
(USING 1977 TECHNOLOGY!)
THAT TAKE MORE THAN SIXTEEN HOURS
TRAVELING AT THE SPEED OF LIGHT
TO REACH THE EARTH.

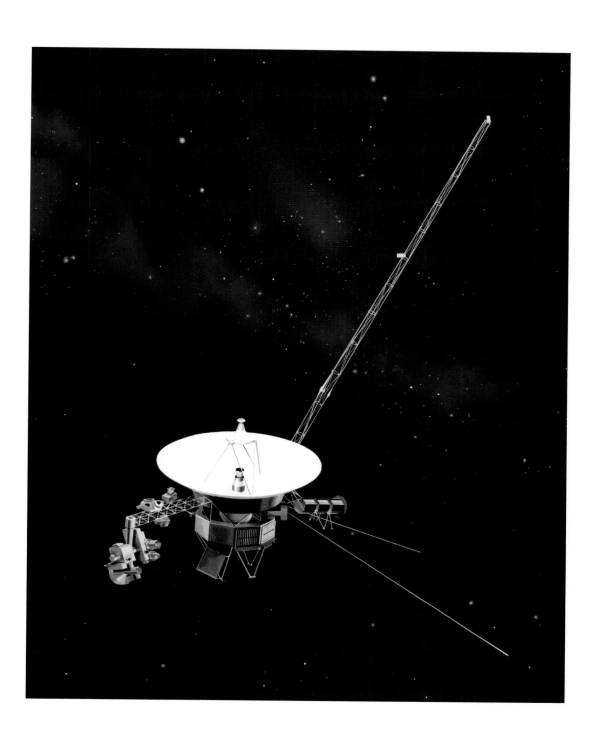

The rest I dedicate to the moon, who, by the bye, of all the Patrons or Matrons I can think of, has most power to set my book agoing, and make the world run mad after it.

– Lawrence Sterne, TRISTRAM SHANDY, vol. 1, ch. IX

CONTENTS

Launching

THE BOOK YOU are now reading is called *Voyager 3* to connect it to its two sturdy, reliable, resilient, flexible, intrepid, relentless, multi-talented real-life namesakes, *Voyager 1* and *Voyager 2*, launched in 1977 and now the furthest man-made objects from the Earth. The word voyage comes from the Old French *veiage*, meaning "travel" or "journey," and further back, from the Late Latin *viaticum*, meaning "journey" or "provisions for a journey," and in turn from the classical Latin *via*, meaning "road," "journey," or "travel."

Voyager 3 takes you on a pioneering journey within, to distant, perhaps heretofore unexamined and surprising realms of yearning, perception, noticing, curiosity, exploration, discovery, understanding, and epiphany.

Voyager 1 AND *Voyager 2*

IN ORDER TO take advantage of the rare geometric alignment and gravitational slingshot assistance of the outer planets Jupiter, Saturn, Uranus, and Neptune (which happens once every 176 years), on August 20, 1977 the National Aeronautics and Space Administration (NASA) launched *Voyager 2*, and then on September 5, 1977, *Voyager 1*, two unmanned interplanetary spacecraft designed to study each of these gas giant planets, their moons and rings, and, on a hopeful yet somewhat wistful trajectory, to proceed on their one-way missions out of our solar system entirely, farther and farther into interstellar space, never to return.

Each of the Jet Propulsion Laboratory–designed *Voyager* space probes weighs 1,592 pounds (722 kilograms) and was sent aloft from Cape Canaveral, Florida, aboard a Titan IIIE/Centaur carrier rocket. *Voyager 1* and *Voyager 2* both carried two sensitive vidicon cameras and other scientific instruments to measure cosmic rays, to detect subatomic particles, and to collect data in the ultraviolet, infrared, and radio wavelengths of the electromagnetic spectrum.

As they passed near to and were slung from one of these four enormous distant planets to the next, by means of at-the-time-of-launch advanced, but by modern standards more rudimentary telemetry than a mobile phone, both spacecraft in their individual and differentiated ways opened the eyes of humanity to astonishing, previously unknown and unimagined conditions of planetary and/or lunar magnetism, weather, volcanic activity, water ice, atmospheric pressure, axial tilt, geological faulting and crustal rifts, coloration, cloud cover, radiation belting, ring particles, and polar topography.

Whole new worlds within worlds. In the words of the English poet John Donne (1572–1631), "Our love can make one little room an every where."

After completing their so-called grand tour of planetary flybys, the *Voyager* siblings pushed on into the trans-heliospheric regions of the solar system. As of April 2010, with *Voyager 2* traveling at a rate of 3.264 astronomical units per year (one astronomical unit is approximately equal to the average distance between the earth and the sun) and *Voyager 1* approximately 10 percent faster, at 3.6 astronomical units per year (about one million miles per day), *Voyager 2* had reached a distance of close to 91.898 astronomical units from the sun (8.542 billion kilometers, or 0.001443 light-years) and Voyager 1 was about 113.158 astronomical units from the Sun (10.518 billion miles, equal to 16.928 billion kilometers, or 0.0018 light-years). Each spacecraft's current location can be found at www.heavens-above.com; information about ongoing telemetry exchanges with *Voyager 1* and *Voyager 2* is contained in *Voyager Weekly Reports* (http://voyager.jpl.nasa.gov/mission/weekly-reports/index.htm); and Twitter regularly posts their current distance to the earth in light-travel time.

Both spacecraft are more than twice the distance from the sun as Pluto, far beyond the most distant reaches of the dwarf planet 90377 Sedna and approaching the outer orbital limits of the dwarf planet Eris. After crossing the heliopause, the extreme boundary of the solar wind, *Voyager 1* and *Voyager 2* enter into the interstellar medium.

Next stop, the stars. If left undisturbed, in about 40,000 years *Voyager 1* will pass within 1.6 light-years (9.3 trillion miles) of the star AC+79 3888 in the constellation Camelopardalis and in about 296,000 years *Voyager 2* will pass within 4.3 light-years (25 trillion miles) of the star Sirius. It is estimated that *Voyager 1* and *Voyager 2* have sufficient electrical power to operate their radio transmitters until at least 2025, more than 48 years after initial launch.

On board each spacecraft is a Voyager Golden Record. This gold-plated copper 16 ⅔ rpm phonograph record contains sounds and images intended to reflect the diversity of science, music, thoughts, and feelings of people on the earth. One of the printed messages on the record says, "We are attempting to survive our time so we may live into yours." A blue-ribbon committee selected 116 photographic and diagrammatic images showing mathematical and physical quantities, a hydrogen molecule diagram, a pulsar map, the solar system, DNA, human anatomy, animals, insects, plants, landscapes, food, and architecture, together with indications of time, size, mass, and chemical composition. The audio portion of the record includes the natural sounds of surf, wind, thunder, the songs of birds and whales, spoken greetings in 55 languages, and musical selections from different cultures and eras, including compositions by Beethoven, Mozart, Bach, Stravinsky, and Chuck Berry.

Each record, as well as this *Voyager 3*, has been prepared for any intelligent extraterrestrial life form, or for future humans, who may come across it. As inscribed in handwriting on the cover of each record, "To the makers of music—all worlds, all times."

Voyagers 1, 2, and *3*: fast, far, independent, and optimistic.

WHAT THIS WRITING IS

CERTAIN MOMENTS CALL out to you. They call attention to themselves. Certain memories and feelings appear to never leave you. Certain sounds, emotions, places, people come back to you from time to time unbidden, with clarity and connectedness, sometimes inextricably bound up with the sacred very words originally chosen to describe them in your mind. The way the late-day aureate September sunlight comes streaming in on a slant through your window. Midsummer lightning bolts finally releasing moisture and unclenching four days' worth of unbearable heat and humidity. Wanting to believe that the vernal scent of lilies of the valley also pours forth from the fields of crocus marching up the side of the hill. Straining to discern sound in the immediate wake of the year's first big snowstorm.

This writing is recounting, recording, recollecting, restoring, remembering. This writing recognizes that everything has value, every second possesses the potential to illuminate, to inspire, to provoke, to teach.

This writing seeks to capture the uncapturable, to describe the indescribable, to speak the ineffable, to paint the unpaintable, to compose the uncomposable. This writing aims to bring time into sharp focus, to slow time down and stop it. This writing wants to reverse time, rewind it, revise it, reorder it, reposition it so as to repossess it.

A picture, a process, infinite possibility, many worlds. Unforgettable clarity, unrelenting awareness, attentiveness, focus.

You have here fifty-four thought photographs: forty-five of one page of text; five of two pages; one of three pages; two of four pages, and one of six pages. Facing each page of writing is a carefully selected photograph, chosen (i) to hint at or reflect the subject matter; (ii) to play off and/or augment feelings engendered by the writing; and (iii) to inspire and provoke you, the reader. In more than a few cases, the photograph has affected, shaped, or reshaped the writing.

With a considerable degree of overlap, ten of these writings evoke a feeling, twenty of the writings take you to a place, seventeen of the writings describe an activity, and seven of the writings limn a state of being.

Many of the writings invoke a "you." Who is "you?" Who are "you?" *You* are you, you are I, you are me, you are child, parent, spouse, friend, beloved, muse, everyone, nobody. She, her, he, him, it, they, them. You, you.

This writing can be read straight through from start to finish or in sequence of any order; one a day or many a day; over a long stretch of time or at one sitting; very slowly or at top speed; silently or out loud; with markings in the margin or on your tablet PC and smartphone.

This writing reflects curiosity about the world, people, places, things, life, love, self.

In many cases, I didn't write these words, they wrote me. I represent merely their spiritual medium, their mediator to you. The words come rushing and gushing out of me onto the page. They

stand out in stars in the night sky, they are spelled out in LED displays on walls, written in aqua-blue neon script above doorways, flashed up on blinking billboards and backlit notebook computer screens.

This writing is a place, an experience, a mood, a painting, the way the light came and went, a song, a color, a laugh, a person, a phrase, the reaction of a crowd, a humorous confluence. This writing wonders if, when, and how you have ever felt or will feel these feelings and sensed these sensations, and then tried to remember them as closely and accurately and reproducibly as possible. This writing is trying to pour you into me, or someone else, as I seek to pour myself into you, or someone else, someplace else, sometime else. And here and now.

This writing is the bringing of the weather, feeling the closeness of the moon, applying sunblock for the stars' nighttime rays. This writing is thinking of how there must be a way to store up the blazing 1:00 p.m. to 4:00 p.m. heat of a peak summer day and use it later to warm you at night, chasing away the shivering.

This writing invites you, cajoles you, urges you, begs you, entreats you, blandishes you to figure out connections waiting to be discovered and coaxed from their hiding place. This writing incites you to forge your own linkages .

This writing searches for your loving love.

WHY I WRITE

I LOVE WRITING. I love the feeling of building up and getting ready to write, with all the postponings of the beginning, the procrastinating, the doing anything else but writing. Cleaning the bathtub. Working on taxes. Writing letters, anything else but what cries out to be written.

I love the act of writing. I love arranging my talismanic writing objects around me. I love getting the writing space just so. I love finally putting down one sentence on paper, another, then another. I love reading over what I've written, liking it, not liking it, making changes, adding, deleting.

I love the physical process of writing. I love using my favorite kind of pen on my favorite kind of paper, filling up the pages as completely as possible, with the slimmest of margins all the way around. I love handwriting. I love my own handwriting. I love getting so caught up in the act of writing that I take short breaths and lose track of time.

I love seeing the world as a child and writing about it, in wonder, awe, worship, amazement, astonishment. I love waking up thinking about writing. I love climbing steps thinking about writing. I love lying there, drifting off to sleep with sentences swirling around me. I love dreaming about writing.

I love imagining through writing what it feels like to be you, and I love trying to make you know through writing what it feels like to be me. I love the backward-and-forward progress of working on a phrase, a passage, a paragraph, a page, a period.

I love trying through writing, to perceive, to personify, to project, to passionify, to provoke, to purify, to pierce, to permeate, to penetrate, to personalize, to participate, to preserve.

I love writing's ability to put me and you and others into orbit, to push the limits of consciousness, to ponder true meanings, to establish whole branching networks of possibility and persuasion and potential.

I love the way writing plays with words and sounds.

I love being obsessed with time and the role of literature and writing in attempting to arrest time, to capture time, to savor time, to appreciate time, to float on the downstream flow of time and simultaneously to fight and swim upstream against the unceasing current of time. Writing allows this, makes it happen, permits it, animates it, reifies it.

Why I Write These Writings

I PUT THESE writings on paper because I am compelled to record and recapture a scene, an insight, a physical sensation, an emotion, an unfolding, a revelation. I write these writings in order to return to them, read them, and re-experience the feelings that brought them into being. The word *pregnant* derives from the Latin words *pre,* meaning "before," and *gignare,* meaning "to bring into being."

I want to read one or two of these complete sketches, at night, before falling asleep, and then dream about it. I like this nocturnal reading method better than trying to balance a big book in bed, reading several lines over and over and trying unsuccessfully to connect them all to the previous day's reading.

In these pages, I seek to capture and store waters behind the dam, and then channel, like a flash flood, the powerful currents of everything meaningful that I have read, seen, tasted, heard, smelled, touched. I seek to hold and fix and communicate the immediacy and urgency of an instant, a fleeting thought, to examine and explore the multiple meanings of experience and noticing. Here, I seek to impart love, questing, searching, attentiveness, concentration, and perception.

I want to make your own heart beat fast, producing physical change to transform you, recollection and recognition and discovery to transfix you. I want you to rip out a page of this that you like, tear it into small strips, and make tea out of it. I want you to cut out passages and tape them up on the inside of the few remaining public telephone booths. I want these writings to give you suppleness, to broaden your fields of interest, to deepen your analytical grasp, and to spark play, recreation, and re-creation.

INFLUENCES ON ME AS I WRITE

I FIND MYSELF writing a meaningful percentage of the time, imagining, composing, juxtaposing, and counterpointing multiple streams and strands and threads, trying them out, listening to them, scribbling them down, and saving them. Or perhaps casting them away in a rushing brook, drifting them downstream on the eddies and currents of a big muddy river, letting them lap the shore and then float away on the seiche of a lake, or watching them recede and disappear into the pounding surf.

What is going on around me influences and informs this writing: travel near and far; writing other books, on asset allocation and investment strategy; public speaking and appearances on television; finding, forwarding, and receiving information on Wikipedia, YouTube, Google, Yahoo, Facebook, MySpace, e-mail, voicemail, mail, magazines, catalogs, and reports; encountering, engaging with, learning from, appreciating, and pumping other people up everywhere; adapting to and adopting technological change, demographic trends, and globalization.

Paintings, sculpture, music, the performing arts, sporting milestones, space launches, books, authors, influence me every day, each one a favorite and simultaneously each one impossible to select as a favorite, each one unique and each one simultaneously strung together with all the others, blended, inseparably mixed, transmogrified on the hard drive of the mind, accessible from the vast computing cloud twenty-four hours a day, seven days a week.

The influential books may be categorized in a certain way: children's books; novels; travelogs; poems. They also offer themselves up according to a host of other rubrics: books you wish you had written; books that are as close to you as yourself; books that are effectively siblings, parents, extended family, or intimate friends; books that never leave you; books that set off explosions of feeling in you; books that have stretched you, captured you, captivated you, overwhelmed you, forever changed you and how you see the world; books that bleed over into and affect how you read other books; books that expand your conception and definition of what a book is and means to accomplish.

In alphabetical order by title, a partial listing of twenty (it's really forty-one) writings that shape me, influence me, make me includes *A Death in the Family* (James Agee), *Anna Karenina* (Leo Tolstoy), *By Grand Central Station I Sat Down and Wept* (Elizabeth Smart), *Conversations with Nadia* (Bruno Monsaingeon), *Eugene Onegin* (Alexander Pushkin), *Gödel, Escher, Bach: An Eternal Golden Braid* (Douglas Hofstadter), *Green Mansions* (W.H. Hudson), *In Search of Lost Time* (Marcel Proust), *Invisible Cities* (Italo Calvino), *Here Is New York* (E.B. White), *Lark Rise to Candleford* (Flora Thompson), *Les Fleurs du Mal* (Charles Baudelaire), *Let Us Now Praise Famous Men* (James Agee), *Letters to a Young Poet* (Rainer Maria Rilke), *Midsummer Night's Dream* (William Shakespeare), *Moby Dick* (Herman Melville), *Night Flight* (Antoine de St. Exupéry), *On Being Blue* (William Gass), *Pale Fire* (Vladimir Nabokov), *Petersburg* (Andrei Bely), *Snow Country* (Yasunari Kawabata), *Sons and Lovers* (D.H. Lawrence), *The Bible: Proverbs, Psalms, Ecclesiastes, Song of Salomon* (King David), *The Canterbury Tales* (Geoffrey Chaucer), *The Dream of the Red Chamber* (Tsao Hsueh-Chin), *The Epic of Gilgamesh* (unknown), *The Hobbit* (J.R.R. Tolkien), *The Little House on the Prairie* (Laura Ingalls Wilder), *The Lover's Discourse* (Roland Barthes), *The Magic Mountain* (Thomas Mann), *The Man Without Qualities* (Robert Musil), *The Once and Future King* (T.H. White), *The Return of the Native*

(Thomas Hardy), *The Sorrows of Young Werther* (Johann Wolfgang von Goethe), *The Tale of Genji* (Lady Shikubu Murakami), *The Wanderer* (Alain Fournier), *Time of Wonder* (Robert McCloskey), *Tristan and Isolde* (Gottfried von Strassburg), *Ulysses* (James Joyce), *War and Peace* (Leo Tolstoy), and *Zen and the Art of Motorcycle Maintenance* (Robert Pirsig).

The List of Writings in *Voyager 3*

SET FORTH ON the following pages is a guide to the fifty-four writings that make up *Voyager 3*. Each entry contains a brief description of the mythological persona for whom the moon is named that titles each writing, the moon's numerical position surrounding its host planet, and its date of discovery. To the right of each moon's name is a brief précis of what inspired the writing, and below each of these descriptions is the name of a painting and a musical composition.

In many cases, an image of the art and the sound of the music were present before me as I wrote and/or revised the writing. Sometimes, visual and auditory elements of each are explicitly or implicitly contained in or adumbrated in the accompanying writing.

The whole point is to try to help you know some part of what it feels like to be me as I write and as I and you read over these writings.

BRIEF DESCRIPTION (PAGE NUMBER)	SUBJECT/LOCATION/ACCOMPANYING ART AND MUSIC
ADRASTEA (2) In Greek mythology, a nymph of Crete to whose care Rhea entrusted the infant Zeus; the fifteenth moon of Jupiter, discovered in July 1979	Being inspired by the moon to dream about and shoot a movie that keeps getting intertwined with the dream Philip Otto Runge, *Morning*, 1809–1810 P.I. Tchaikovsky, "Serenade for Strings in C Major"
RHEA (4) An ancient Greek goddess, daughter of Kronos and mother of Zeus; the fifth moon of Saturn, discovered December 23, 1672	At Elmendorf Air Force Base in Anchorage, Alaska, piloting the F-16 Fighting Falcon and the F-15 Strike Eagle John Atkinson Grimshaw, *Golden Light*, 1893 Earth Wind and Fire, "In the Stone"
YMIR (6) The primordial Norse giant and progenitor of the race of frost giants; the nineteenth moon of Saturn, discovered August 7, 2000	Descending by airplane in the twilight to Boston's Logan Airport Mark Stock, *The Butler in Love-Absinthe*, 1989 George Benson, "Breezin'"
SETEBOS (9) A South American deity popularized as Syncorax's god in Shakespeare's *The Tempest*; the nineteenth moon of Uranus, discovered July 18, 1999	Running to the Château de Chillon alongside Lake Geneva Caspar David Friedrich, *The Wanderer Above the Mists*, 1817–1818 Tavares, "It Only Takes a Minute"
HI'IAKA (12) The larger outer moon of the Kuiper Belt dwarf planet Haumea; patron goddess of the island of Hawaii and of hula dancers; discovered January 26, 2005	Aircraft takeoffs and landings on the carrier USS America Maxfield Parrish, *Ecstasy*, 1929 R. Kelly, "Ignition Remix"
AMALTHEA (15) A naiad who nursed the newborn Jupiter and nourished him with the aid of a goat; the fifth moon of Jupiter, discovered September 9, 1892	Running beside the Hudson River in Sleepy Hollow, Westchester County, New York Vasily Kandinsky, *Riding Couple*, 1906 Joe Sample, "Carmel"
PHOEBE (16) A mythical Greek titaness known as the "golden-wreathed"; the ninth moon of Saturn, discovered August 16, 1898	Hearing a song on the radio crossing the Verrazano-Narrows Bridge between Brooklyn and Staten Island and connecting it to taking photographs in the shoreline marshes of Westport, Connecticut Emil Nolde, *Wildly Dancing Children*, 1909 Teri De Sario, "Ain't Nothing Gonna Keep Me From You"
PHOBOS (18) One of the horses that drew Mars's chariot and the embodiment of fear and horror in Greek mythology; the larger of the two Martian moons, discovered August 17, 1877	Boating in Central Park in the summertime Gustav Klimt, *Farm Garden*, 1906 David Benoit, "Kei's Song"

BRIEF DESCRIPTION (PAGE NUMBER)	SUBJECT/LOCATION/ACCOMPANYING ART AND MUSIC
PANDORA (20) The first woman in Greek mythology; made of clay by Hephaestus at the request of Zeus, she married Epimetheus and opened a pithos box releasing misfortunes upon humankind; the 17th moon of Saturn, discovered in October 1980	The role of letters, e-mail, and texting in a relationship Ernst Ludwig Kirchner, *Winter Landscape in Moonlight*, 1919 SWV, "Right Here (Human Nature Mix)"
PROTEUS (23) Sea-god of Greek mythology; son of Oceanus and Tethys; the 8th moon of Neptune, discovered in June 1989	On the cusp between fall and winter, climbing to the castle overlooking Ljubljana, Slovenia Charles Burchfield, *The Four Seasons*, 1949-1960 Barry White, "My Sweet Summer Suite"
LYSITHEA (24) Daughter of Kadmos, also named Semele, mother of Dionysos by Zeus; the tenth moon of Jupiter, discovered July 6, 1938	Brazil as a possible new homeland Richard Diebenkorn, *Cityscape (Landscape No. 1)*, 1963 Antonio Carlos Jobim, "Aguas de Março"
TETHYS (26) Aquatic sea goddess, the daughter of Uranus and Gaia, wife of Oceanus, and mother of all rivers and Oceanids; the third moon of Saturn, discovered March 21, 1684	Tropical storms hitting the Kinta River Valley of Malaysia and the Fullerton Hotel (formerly the Colonial UK Post Office) in Singapore Joan Mitchell, *Two Pianos*, 1979 Ryan Shaw, "We Got Love"
MAB (29) A fairy queen in Shakespeare's *Romeo and Juliet*, she enters the brains of sleeping people to compel them to experience dreams of wish fulfillment; the twenty-sixth moon of Uranus, discovered August 25, 2003	Crossing a covered bridge in Vermont in winter Ferdinand Hodler, *Lake Geneva from Chexbres*, 1904 Igor Stavinsky, "Firebird Suite"
SELENE (30) "Far-winged" daughter of the Titans Hyperion and Thea, her name likely derives from the Greek selas ("brightness"); the only moon of Earth	Traveling to and thinking about Pacific Asia Sara Eyestone, *Chintz*, 1999 Sly and the Family Stone, "Hot Fun in the Summertime"
LINUS (32) The son of the Greek Muse Kalliope, the inventor of melody and rhythm; orbits the large M-type asteroid 22 Kalliope; discovered August 29 and September 2, 2001	Street acrobats in Battery Park, New York City Adolf von Menzel, *View From a Window in the Marienstrasse*, 1867 Phyllis Hyman, "You Know How to Love Me"

Brief Description (Page Number)	Subject/Location/Accompanying Art and Music
Titania (35) The Queen of the Fairies in Shakespeare's *A Midsummer Night's Dream*; the third moon of Uranus, discovered January 11, 1787	Deep snow in Maine, Quebec, and Ontario Nelson C. White, *Stream and Rapids Night*, 1954 Joan Armatrading, "Show Some Emotion"
Oberon (36) The King of the Fairies and of Shadows in Shakespeare's *A Midsummer Night's Dream*; the fourth moon of Uranus, discovered January 11, 1787	Ascending the triple-helix tunnels past the Wassenkirche in Switzerland's Canton Uri before entering the Gotthard rail tunnel at Göschenen Edgar Degas, *Woman with Chrysanthemums,* 1865 Frédéric Chopin, "Etude Opus 10 No. 1 in C Major"
Nereid (38) The 50 sea-nymph daughters of Nereus and Doris; attendants of Neptune, Roman god of the sea; the second moon of Neptune, discovered May 1, 1949	The fountain and colonial architecture of the Parque Central in Antigua, Guatemala Ando Hiroshige, *Great Bridge, Sudden Shower at Atake*, 1856 Lester Flatt and Earl Scruggs, "Orange Blossom Special"
Dione (41) The sister of Cronos and the mother (by Zeus) of Aphrodite; the fourth moon of Saturn, discovered March 21, 1684	Listening to a story on the radio while driving through the Scottish Highlands via routes A9, A889, A86, A82, A87, and A863 to the Isle of Skye Georgia O'Keeffe, *Red Canna*, 1923 John Sebastian, "Welcome Back"
Miranda (44) The beautiful daughter of the old Duke Prospero and the only female character in Shakespeare's *The Tempest*; the fifth moon of Saturn, discovered February 16, 1948	Flora and fauna in the rainforest canopy above San Pedro Sula, Honduras Max Beckmann, *Woman with Mandolin in Yellow and Red*, 1950 Sixpence None the Richer, "Kiss Me"
Mimas (46) Son of Gaia in Greek mythology, one of the Giants slain by Heracles; the first moon of Saturn, discovered July 18, 1789	Comings and goings in New York City's Bryant Park Edward Hopper, *The Lighthouse at Two Lights*, 1929 Cécile Chaminade, "Concertino for Flute and Piano, Opus 107"
Titan (49) Descendents of Gaia and Uranus, a race of powerful deities that ruled during the legendary Golden Age in Greek mythology; the sixth and largest moon of Saturn, and the only natural satellite known to have a dense atmosphere; discovered March 25, 1655	Traveling the Karakoram Highway in the Himalayas Charles Demuth, *The Figure Five in Gold*, 1928 David Sanborn, "Bums Cathedral"

Brief Description (Page Number)	Subject/Location/Accompanying Art and Music
Sinope (59) One of the daughters of the river god Asopus; irregular-shaped and ninth moon of Jupiter, discovered July 21, 1914	The train station in Zurich giving passage to the Lake of Zurich Wayne Thiebaud, *Boston Cremes,* 1969 Buckwheat Zydeco, "Hard to Stop"
Triton (60) Son of Poseidon and Amphitrite, the messenger of the deep; the largest moon of Neptune, discovered October 10, 1846	In Cambodia, Angkor Wat's relationship to Tonle Sap Lake and the Mekong River Giovanni Segantini, *The Evil Mothers*, 1894 Abba, "SOS"
Tarvos (62) A Gallic deity depicted as a bull god carrying three cranes alongside its back; the twenty-first moon of Saturn, discovered November 9, 2000	Watching someone comb her hair while projecting yourself into her and text-messaging her thoughts Martin Johnson Heade, *Cattleya Orchid and Three Hummingbirds*, 1871 Kim Carnes, "More Love"
Albiorix (64) A Gallic giant who was considered to be king of the world; the twenty-sixth moon of Saturn, discovered November 9, 2000	University Place and Washington Square Park in Greenwich Village, New York City Johannes Vermeer, *A Lady Writing*, 1665 The Style Council, "My Ever Changing Moods"
Prometheus (67) Son of the Titan Iapetus, brother of Atlas and Epimetheus, he stole fire from Zeus and gave it to mortals for their use; the sixteenth moon of Saturn, discovered in October 1980	The legend of the islands of Hawaii splitting apart and, someday in the future, re-fusing into one landmass Frederic Edwin Church, *In the Andes*, 1878 Focus, "Sylvia"
Umbriel (68) The melancholy sprite in Alexander Pope's *The Rape of the Lock*; the second moon of Uranus, discovered October 24, 1851	Picnicking in Fort Greene Park, Brooklyn John Singer Sargent, *Carnation, Lily, Lily, Rose,* 1885–1886 GQ, "Make My Dream a Reality"
Leda (70) Queen of Sparta, seduced by Zeus in the guise of a swan, resulting in the birth of Helen of Troy, Clytemnestra, and Castor and Pollux; the thirteenth moon of Jupiter, discovered September 11, 1974	The Brooklyn Botanic Garden in full cherry blossom Howard Pyle, *The Mermaid*, 1910 Diana Ross, "I'm Coming Out"
Iapetus (72) A Titan, the son of Uranus and Gaia, and father of Atlas, Prometheus, Epimetheus, and Menoetius; the eighth and two-toned moon of Saturn, discovered October 25, 1671	Different embodiments of the Mekong River flowing through the three main regions of Laos: mountains, plains, and deltas Frederick Carl Frieseke, *The Birdcage*, 1910 Luther Vandross, "Shine"

Brief Description (Page Number)	Subject/Location/Accompanying Art and Music
ANANKE (74) Mother of Adrastea by Zeus, she was the goddess of fate, destiny, and necessity, depicted holding a spindle; the twelfth moon of Jupiter, discovered September 28, 1951	The culture and geography of Trinidad and Tobago Childe Hassam, *Allies Day*, 1917 Young and Company, "I Like What You're Doing to Me"
JANUS (77) The Roman god of gates, doors, doorways, beginnings, and endings; the tenth moon of Saturn, discovered December 15, 1966	The pragmatics and philosophy of drag racing John Henry Twachtman, *October*, 1901 Convertion, "Let's Do It"
EPIMETHEUS (78) A Titan and the inseparable brother of Prometheus; his name means "hindsight" or "afterthought"; he was responsible for giving a positive trait to every animal; the eleventh moon of Saturn, discovered in 1977 and on February 26, 1980	Time- and space-projecting one's self into Melbourne, Australia Diego Velasquez, *The Waterseller of Seville*, 1620 Stevie Wonder, "I Was Made to Love Her"
DYSNOMIA (80) The daughter of the Greek goddess Eris, her name in Greek means "lawlessness"; the only known moon of the dwarf planet Eris (meaning "strife"), the largest dwarf planet in the solar system (27 percent larger than Pluto); discovered September 10, 2005	Following the course of the sun for one full day in Miami André Derain, *Boats in the Port of Collioure*, 1905 Miami Sound Machine, "The Words Get in the Way"
NIX (82) The goddess of darkness and night, mother of Charon; the second moon of Pluto, discovered May 15, 2005	Plumbing the mysteries of California and Nevada's Lake Tahoe (1,645 feet), after Crater Lake (1,945 feet), the second-deepest lake in the United States Umberto Boccioni, *The Street Enters the House*, 1911 Cam'Ron, "Oh Boy featuring Juelz Santana"
CALLISTO (85) Daughter of Lycaon and a nymph associated with Artemis, the goddess of the hunt; she was transformed into a bear as Ursa Major and in Greek mythology circles the North Pole with Arcas, Ursa Minor; the fourth moon of Jupiter, discovered January 7, 1610	Making a movie about the shattering amaranthine beauty of Capri Katsushika Hokusai, *The Great Wave off Kanagawa*, 1826–1833 Janet Jackson, "Together Again"

Brief Description (Page Number)	Subject/Location/Accompanying Art and Music
Europa (91) Beautiful daughter of Agenor, the Phoenician king of Tyre, she was abducted by Zeus, who assumed the shape of a white bull; with her on his back he swam to Crete, where she bore him three sons: Mino, Rhadamanthus, and Sarpedon; the second moon of Jupiter, discovered January 8, 1610	With Gael, Marc, and Laure, exploring the towns, language, customs, and coastline of Brittany Milton Avery, *Speedboat's Wake,* 1959 Prince, "Little Red Corvette"
Enceladus (96) One of the Giants, the enormous children of Gaia (Earth) fertilized by the blood of castrated Uranus; during the battle between the Giants and the Olympian gods, Enceladus was disabled by a spear thrown by Athena and is buried under Sicily's Mount Etna (whose volcanic fires are said to be his breath); the second moon of Saturn, discovered August 28, 1789	Rainbows and moonlight Manhattanhenging Brooklyn, Queens, the Bronx, and Staten Island Claude Monet, *Impression, Sunrise,* 1872 Stevie B, "I Wanna Be the One"
Hyperion (99) Titan god, brother of Cronus and the lord of light; the seventh moon of Saturn, discovered September 16, 1848	The aquatic, engineering, and nautical wonders of the Panama Canal Tamara de Lempicka, *Young Lady with Gloves,* 1930 Elvis Presley, "Marie's the Name (His Latest Flame)"
Ariel (100) The leading guardian spirit in Alexander Pope's poem *The Rape of the Lock*; the first moon of Uranus, discovered September 16, 1848	What the Mayan people were seeking to accomplish with their temples in Belize Sandro Botticelli, *The Birth of Venus,* 1486 Elton John, "Philadelphia Freedom"
Metis (102) Meaning "wisdom," "skill," or "craft," the daughter of Oceanus and Tethys, and first wife of Zeus, who swallowed her in the form of a fly when she became pregnant, and then gave birth to fully clothed, armed, and armored Athena through his forehead; the sixteenth moon of Jupiter, discovered March 4, 1979	Snow and rain on forests and rivers in the Pacific Northwest Marsden Hartley, *Mt. Katahdin, Maine #2,* 1939-1940 The Jackson Five, "I Want You Back"
Thebe (105) A nymph in Greek mythology, daughter of Asopus and Metope, wife of Zethus; Zeus loved her; she helped construct the city of Thebes; the fourteenth moon of Jupiter, discovered March 5, 1979	The Burning Man Festival in Nevada John Everett Millais, *The Blind Girl,* 1856 Madonna, "Holiday"

Brief Description (Page Number)	Subject/Location/Accompanying Art and Music
Elara (108) Daughter of King Orchomenus, a paramour of Zeus, and by him the mother of the giant Tityos; the seventh moon of Jupiter, discovered January 3, 1905	Fly Hot Springs near Gerlach, Nevada Dante Gabriel Rossetti, *The Blessed Damozel*, 1875–1881 Miley Cyrus, "Party in the USA"
Deimos (110) The son of Ares (Mars in Latin) and Aphrodite; meaning "dread," the personification of terror and one of the horses that drew Mars's chariot; the second moon of Mars, discovered August 11, 1877	Black Rock City in Nevada Mark Rothko, *Orange and Yellow*, 1956 Phil Collins, "Behind the Lines"
Himalia (113) Meaning "abundant," a nymph from the island of Rhodes who was enamored by Zeus and bore him three sons: Spartaios, Kronios, and Kytos; the sixth moon of Jupiter, discovered December 4, 1904	Pyramid Lake near Empire, Nevada Leonardo de Vinci, *Madonna of the Rocks*, 1483–1486 The Fatback Band, "I Found Lovin'"
Atlas (116) The Titan son of Iapetus and Clymene, he stands at the western edge of Gaia (Earth) and supports the sky on his shoulders; the fiftheenth moon of Saturn, discovered in October 1980	Fire cannons at the Burning Man Festival Joaquín Sorolla y Bastida, *Walk on the Beach*, 1909 Daryl Hall and John Oates, "Rich Girl"
Io (119) Priestess of Hera in Argos who was seduced by Zeus, who changed her into a heifer to escape Hera's wrath; the first moon of Jupiter, discovered January 8, 1610	A once-in-a-century snowstorm hitting New York City N.C. Wyeth, *The Midnight Encounter*, 1924 Joan Armatrading, "Show Some Emotion"
Paaliaq (122) A giant in Inuit mythology; the twentieth moon of Saturn, discovered August 7, 2000	Whether a non-Chicagoan can experience Chicago as a Chicagoan does Winslow Homer, *The Fox Hunt*, 1893 Chicago, "Does Anybody Really Know What Time It Is?"
Pasiphaë (124) Meaning "wide shining," the daughter of Helios (the sun) by the eldest of the Oceanids, Perse; she gave birth to the Minotaur and was a mistress of magical herbal arts; the eighth moon of Jupiter, discovered January 27, 1908	Ft. Greene, Brooklyn Norman Rockwell, *Girl at Mirror*, 1954 Ronnie Laws, "Always There"

Brief Description (Page Number)	Subject/Location/Accompanying Art and Music
PAN (127) Greek god of fertility, pastoralism, shepherds, hunting, and rustic music, depicted with the hindquarters, legs, and horns of a goat; connected to fertility and the season of spring; the eighteenth moon of Saturn, discovered in 1990	Hudson River Park riverbank, on the West Side of Manhattan Raphael Sanzio da Urbino, *The Small Cowper Madonna*, 1505 Andy Gibb, "I Just Want to Be Your Everything"
GANYMEDE (129) The most handsome among mortals, by reason of which he was abducted by Zeus from Troy in the form of an eagle to serve as cupbearer to the gods; the third moon of Jupiter, discovered January 7, 1610	Running up Black's Link to Jardine's Lookout in Hong Kong Yayoi Kusama, *Dots Obsession*, 2000 Two Tons of Fun, "Just Us"
CARME (135) Meaning "shearer," the mother by Zeus of the virginal huntress Britomartis; a Cretan spirit who assisted in the grain harvest of Demeter's Cretan predecessor; the eleventh moon of Jupiter, discovered July 30, 1938	Stafford Springs, Somers, and Somersville, Connecticut Edouard Manet, *The Luncheon on the Grass*, 1862–1863 America, "Ventura Highway"
CHARON (138) Meaning "of keen gaze," the mythological ferryman of Hades who carries to Pluto for judgment the souls of the newly deceased across the rivers Styx and Acheron that divide the world of the living from the world of the dead; first moon of the dwarf planet Pluto, discovered April 13, 1978	In the Tillamook neighborhood of Portland, Oregon Frederic Leighton, *Flaming June*, 1895 Dan Hartman, "Relight My Fire"
THELXINOË (140) "Mind Charming," a name attributed to (i) one of the sirens; (ii) one of four muses and a daughter of Zeus; and (iii) one of Semele's attendants; the forty-second moon of Jupiter, discovered February 9, 2003	Fog closing in around the twin towers of the World Trade Center in Lower Manhattan Pablo Picasso, *Les Demoiselles d'Avignon*, 1905 Sanford Townsend Band, "Smoke From a Distant Fire"

Why these Writings Are Named after Moons

Most of the moons in our solar system are named after gods, and then these writings, these thought-photographs, are named after moons. Underlying the whole process is gravity, naming, word spellings, word origins, and meanings.

Gravity is everywhere. It operates over large distances and can bend light through space-time curvature. It governs the motion of inertial objects. It pulled the universe together, yet its essential workings remain incompletely explained. Anomalies and discrepancies abound. Hypotheses and observations are variously built upon the exchange of virtual gravitons, gravitational radiation, quantum gravity, string theory, M-theory, loop quantum gravity, or casual dynamical triangulation. Alternative explanations, modifications, and proposals compete for attention and verification.

The heterogeneous moons that name these writings can be grouped in many ways: according to their size, color, and mineral composition; the body around which they orbit; the character of their path through the skies; and when and how they were discovered.

I love the fact that they've been formed through capture, collision, or coalescence. I love that they've been there a long time without our knowing about them, far away, silent, unseen, subject to mathematically computable paths and partially but not completely understood mutual gravitational forces. Images of these new moons inspire awe, reflection, curiosity, amazement, reverence, sublimity, stupefaction, admiration, curiosity, veneration, astonishment.

For centuries, poets have described our earth's moon, and without realizing it, other wandering planets' moons, as watery, splendid, papery, wandering, pale, unfathomable, misty, companionless, cold, warm, ever-changing, imperturbable, climbing, serene, placid, plaintive, ready, sweet, fading, poised, fleet, fulfilling, empty, solemn, golden, silver, white, black, dark, bright, pink, red, orange, indigo, green, aquamarine, blue, dun, dim, faint, floating, fleeting, indolent, caressing, restless, silken, tilted, lustrous, shining, shimmering, half-sized, and twice-sized.

All these writings derive from a similar alpha and share a similar omega.

Nostra Luna, Our Moon

Prevailing theories hold that our moon was formed as a result of an enormous Mars-sized body slamming into earth shortly after our own planet was formed, about 4.53 billion years ago. The word *moon* derives from the Proto-Indo-European root *me-*, which refers to "time" and "measurement." At one-quarter of the earth's diameter, one eighty-first of the earth's mass, and one-tenth of the earth's surface area, our moon is the fifth-largest moon in the solar system and the brightest object in our sky after the sun.

The moon's gravitational pull on the earth is manifested in the ocean tides, augmented and countered by the gravitational attraction of the sun (almost half that of the moon). Gravitational coupling is imperceptibly yet inexorably slowing down the earth's rotation, adding about fifteen mi-

croseconds each year to the length of the earth's day and thus necessitating the occasional insertion of a leap second into our calendars.

Ever-present, ever-changing, silent, oneiric, mystical, magical, unfathomable, omenic, provocative, beautiful, hypnotic, mysterious, loyal. For millennia, our moon has affected and informed mythology, literature, art, religion, music, culture, and language itself. In Asia, mooncakes, linked to Chang'e, the mythical Moon Goddess of Immortality, are eaten during the Mid-Autumn/Zhongqiu Festival devoted to lunar worship and moon watching. The moon's hourly, daily, monthly, yearly, and decadal movements in the sky have been noticed, tracked, calculated, depicted, and written about by astronomers and astrologers, by shepherds and sailors, by painters and poets, by priests and pagans, by astronauts and astrophysicists.

Humans first landed on the moon in July 1969, and on six subsequent Apollo missions between 1969 and 1972. These expeditions have returned 836 pounds (380 kilograms) of lunar rocks. Human beings have not set foot on the moon since 1972, instead sending lunar rovers and unmanned spacecraft for mapping, sample collection, and analysis. Since 2004, lunar orbiters have been sent to the moon by China, the European Space Agency, India, Japan, and the United States. Under the Outer Space Treaty of 1967 (formally known as the Treaty on Principles Governing the Activities of States in the Exploration of Outer Space), the moon remains free to all nations to explore for peaceful purposes.

THE DISCOVERY OF OTHER MOONS

SPOTTED THROUGH HIS 30-magnification telescope by Galileo in January 1610, four moons of Jupiter (Io, Europa, Ganymede, and Callisto) were the first celestial objects that were confirmed to orbit an object other than the earth. The next 360 or so years witnessed the visual observation of approximately 32 moons circling several of the other planets in the solar system. The *Voyager 1* and *Voyager 2* spacecraft missions led to the discovery of another 35 moons in the 1980s and 1990s, and the years since 2000 have drawn both on orbiting and on large ground-based optical telescopes to identify more than 250 bodies formally classified as moons.

As of late 2009, 427 bodies in our solar system have been officially categorized as moons. More than 168 moons are confirmed in orbit around six of the eight planets: around Mercury, none; around Venus, none; around the earth, one; around Mars, two; around Jupiter, 63; around Saturn, 62 (53 of which have names, and most of which are quite small, with over 150 additional diminutive and as yet unclassified objects having been tracked within the ring system of Saturn); around Uranus, 27; and around Neptune, 13. Another six moons orbit three of the five dwarf planets, 190 bodies are known as minor-planet or asteroid moons, and 63 objects are known to be moons of Trans-Neptunian objects.

Although it is likely that moons circle the 453 known extrasolar planets that have been discovered since 1992 orbiting suns outside our solar system, none of these extrasolar moons have yet been observed.

The Naming of Moons

SINCE 1973, THE International Astronomical Union's committee for planetary system naming, known as the Working Group for Planetary System Nomenclature, has been responsible for assigning names to moons, with Roman numerals assigned to each planet's moons more or less in the order of their discovery. Before 1973, the identification of moons besides the earth's moon produced name choices that were usually determined by their discoverer. Mars's two moons, named after the two sons of the Roman god Mars (Ares in Greek mythology), were named by Asaph Hall in 1878, soon after he discovered them.

Jupiter's moons are named after lovers, descendants, favorites, or daughters of the mythological god Jupiter (Zeus in Greek mythology), with prograde moons having names ending in a or o and retrograde moons' names ending in e. Saturn's moons are named after mythological Greek giants, Titans, and Titanesses. With the increasing number of moons that have been and are being discovered around Saturn, depending on their position, satellites of that planet have been named after Norse giants, after Gallic giants, and after Inuit giants.

Uranus's moons are named after magical spirits and other characters in William Shakespeare's plays and in Alexander Pope's poem *The Rape of the Lock*. Neptunian moons are named after Greek and Roman sea deities. Pluto's moons are named after Greek mythological characters associated with Hades (the Greek equivalent of Pluto). Eris's moon Dysnomia is named after Eris's mythological daughter, and Haumea's moons are named after her daughters in Hawaiian mythology. Thus far, the named moons of asteroids and Kuiper Belt Objects have generally been taken from Greek and Roman mythology.

The Classification and Characteristics of Moons

MOONS ARE GENERALLY believed to have been formed by (i) the gravitational capture of fragmented asteroids and/or comets; (ii) the collision of two large proto-planetary objects; or (iii) the same spinning, collapsing, reaccreting process that created their underlying host planet.

Moons tend to be classified according to the character of their orbits. Regular moons usually lie close to the plane of their planet's orbit and travel in the direction of their underlying planet's rotation (called prograde orbits). Irregular moons, which are broadly considered to have once been minor planets that were at some point in time gravitationally captured from nearby space, usually lie at extreme angles to their underlying planet's equators and may orbit either in the same or in the opposite direction (retrograde) of their underlying planet's orbit.

Several of the solar system's many moons remain geologically and/or meteorologically active, featuring impact craters, dunes, volcanism, solidified pools of basaltic lava, tectonic activity, gravity, comminuted regolith, magnetic fields, fissures, geysers, rocks, methane lakes, and in some cases, atmospheres and mists. Jupiter's moon Io is considered to be the most volcanically active body in the entire solar system.

Some moons in the solar system have active unusual characteristics, such as (i) rotation periods vastly different from their orbital periods; (ii) sibling moons orbiting the same primary body, in a different orbit; or (iii) companion co-orbital or Trojan moons following the exact same orbit, sixty degrees ahead of and behind the primary moon. Other moons are suspected (though not yet confirmed) to feature rain or subsurface oceans of liquid water.

Full Moons and Lunar Eclipses

A lunar eclipse takes place only during a full moon phase and occurs when the earth blocks solar illumination by passing between the sun and the moon. In contrast to solar eclipses, which last for a few minutes as they transit only a limited swath of the earth, a lunar eclipse lasts for a few hours and may be observed from any position on the night side of the earth. As with total solar eclipses, total lunar eclipses are relatively rare events. Partial lunar eclipses occur twice each year.

A full moon occurs when the moon lines up on the opposite side of the earth from the sun. Full moons are believed to be associated with magical events, insomnia, and varying degrees of insanity. Since ancient times, numerous cultures have assigned special names to each full moon. For example, the winter months' full moons (in modern-day January, February, and March) were known by the Native American Algonquian peoples as the Wolf Moon, the Snow Moon, and the Worm Moon; April, May, and June were known as the Pink Moon, the Flower Moon, and the Strawberry Moon; July, August, and September were known as the Buck Moon, the Sturgeon Moon, and the Harvest Moon; and October, November, and December were known as the Hunter's Moon, the Beaver Moon, and the Cold Moon.

Because each calendrical year contains an average of 12.37 full moons, every 2.7 years one of the four seasons contains four full moons rather than three, with the third of these four known as a blue moon. For several decades during the twentieth century, a second full moon occurring within a calendar month was broadly (and mistakenly) known as a blue moon.

New Moons and Solar Eclipses

When the moon lines up directly between the earth and the sun, the dark side of the moon faces directly towards the earth and thus is not visible to the naked eye. This conjunction alignment, known as a new moon, heralds the beginning of the month in lunar and/or lunisolar calendars, including the Chinese, the Thai, the Islamic or Hijiri, the Tibetan, the Julian and Gregorian, the French Republican, the Bangladeshi, the Sinhala, the Icelandic/Old Norse, the Old English, the Nisga'a, the Old Egyptian, the Iranian/Persian, the Old Hungarian, the Tamil, the Tongan, the Buddhist, the Hebrew, the Mayan, the Badi (Baha'i Faith), the Neo-pagan, the Germanic, the Celtic, and several Hindu calendars. A new moon is also an important event in Wicca and, together with a full moon, plays an important role in astrology.

With the sun approximately 390 times farther away from the earth than is the moon, and with the sun's diameter about 400 times the moon's diameter, solar eclipses can only take place during a new moon, with at least two and no more than five solar eclipses occurring each year. A maximum of two such eclipses can be total eclipses. Owing to the disappearance of the sun and the darkening of the sky during daytime in total solar eclipses, in centuries past and in some cultures even today, total solar eclipses have been attributed to supernatural causes and often perceived as unfavorable signs.

Driven by the shape and position of the moon's orbit, total solar eclipses race across the earth's surface at over 1,000 miles per hour (1,700 kilometers per hour) and can last at a given location for a maximum of 7 minutes and 31 seconds. The longest total solar eclipse of the 21st century took place on July 22, 2009, lasting 6 minutes 39 seconds, and the next total solar eclipse with a duration of longer than 7 minutes will not happen until June 25, 2150.

On a grand time scale, total solar eclipses as witnessable from the earth are relatively rare. Owing to tidal acceleration, the orbit of the moon moves roughly 1.6 inches (4.06 centimeters) farther away from the earth each year. In roughly 600 million years (when the sun will actually have grown in size), the moon's distance from the earth will be 12,000 miles (23,500 kilometers) farther away than it is than today, and thus no longer able to totally cover the sun's disk in a solar eclipse. This means that the last total solar eclipse on the earth will take place somewhat less than 6 million centuries (600,000 millennia) from now.

Archaeological texts of Assyria, Babylonia, China, India, and Greece associate total solar eclipses with portents, omens, revelations, and the onset (or cessation) of events such as epic battles, floods, or royal dethronings. Because being able to predict in advance the timing and location of total solar eclipses could represent a significant strategic advantage, intelligent astronomers of ancient Assyria and Babylonia were able to compute the subtle, complicated, and intersecting intricacies of the moon's major positional movements in the sky.

These movements include (i) the moon's monthly orbital period around the earth to get back to its actual original position relative to the stars and the universe as a whole (known as a sidereal month, equal to 27.32 days); (ii) its monthly orbital period around the earth to get back to its apparent original position, taking into account the fact that the earth will have moved about one-twelfth of the distance in its own orbit around the sun (known as a synodic or lunar month, equal to 29.53 days); (iii) the gradual, 18.6-year back-and-forth movement of the moon's own orbit, from five degrees above to five degrees below the ecliptic, which is the plane of the earth's orbit around the sun (known as a draconic month, equal to 27.21 days); and (iv) the nine-year complete circuit of the forward movement of the moon's perigee, with the time between one perigee and the next known as an anomalistic month, equal to 27.55 days.

After close, careful, and persistent watching and calculation, a few ingenious lunar observers came to the realization that for the moon, the sun, and the earth to line up in the same place for a solar eclipse, 223 synodic months (6,585.3213 days) would have to pretty closely equal 242 draconic months and 239 anomalistic months. Such alignments are true with an accuracy of about 2 hours. This 18-year, 11⅓-day periodicity can be used to predict solar eclipses and is known as the Saros

cycle. In 1671, the British astronomer Edmund Halley first applied the term *Saros* to this cycle from the Sumerian/Babylonian word *Šár*, an ancient Mesopotamian unit of measurement, having an apparent value of 3600.

Recognizing that the ⅓ day at the end of this important equivalence means that successive Saros solar eclipses move 120 degrees, or one-third of the way around the earth each time they occur, an earth-based observer actually needs three Saroses (equal to 54 years and one month, or almost 19,756 full days) for a solar eclipse to line up in the exact same spot. This is known as a Triple Saros, or *exeligmos*, which in Greek means "turn of the wheel."

Total solar eclipses can occur on other planets when any of the planet's moons are large enough, close enough, and properly orbitally positioned to completely occult (block out) the sun. For example, five of Jupiter's sixty-three moons are capable of eclipsing the sun to an observer located on Jupiter: Amalthea, Callisto, Europa, Ganymede, and Io.

Envoi

Enjoy your journey.

VOYAGER 3

ADRASTEA

Oh My, the moon was so huge, sitting up there in the sky, so astonishingly fat and close, although I don't normally keep track of such things, that when it jumped above the horizon, I seemed to remember that it was due, it was coming, I knew the full moon was rising and I wanted to see it everywhere, I ran through the tall grasses and the trees, watching it climb and shine back on me, casting shadows; at every single stoplight, I would get out of the car and there she was, big, round, heavy, silvery, buttery, omnipresent, all-seeing, dream-inducing, and that was the climax in the dream that night, the whole barn burns down, it was too cold that winter to bury his uncle, the ground was frozen solid, I was trying to film the scene with a videocam, the lantern—with the moon shining through its little windows—blew off its hook in the wind and crashed to the ground next to some hay, and nothing happened for five seconds; I was waiting; it didn't seem like it was going to work, and I was anxious adjusting the lenses and the buttons because I knew that I had to get it in the first take and then suddenly, the fire caught, and the trails of kerosene that I had somehow poured wound up the walls and around the windows and they lit up in sequence, like plugging in string after string of Christmas lights, and then I ran out from under the flaming beams and timbers and the collapsing joists and girders, to try to catch the toppling cupola from the yard, and now the whole sky was on fire, not from the barn, but from the moon and the clippering clouds and the frigid air, all pinks and magentas and fuchsias and this popsicle orange on the underside; I knew it was going to be the best thing I'd ever shot so far, digitizing it, nonlinearizing it like reordering the cars in a freight train, and instantly you were there, a mermaid, barefooted with a skyblue sequined dress and it was sparkling like diamonds to the sound of the sparking barn and I was so nervous because I had been wanting to see you ever since I was fourteen and had copied down the words to the song from the radio back then and I sang every single note with you; I was in heaven I was in ecstatic rapture I didn't know what to do I drank two full bottles of champagne fast just to contain myself

Rhea

For the faster ones, it took four years to learn, but on average, it took at least seven years to master all of its systems, all this because you've only got at most one second when it comes down to it, and you've got to have anticipated and rehearsed that one second a million times, splitting it, subdividing it, breaking it down into 10,000 pieces out of respect for the equipment, your role, the damage you can wreak and the damage to your well-being, the way the air has to be rammed and crammed, roomed and groomed, a whole other language and alphabet used to describe it, a whole other meaning ascribed to words like lordship, and superiority, and strike, always a she and even in the electronic world, the emphasis was on the visual, this blend of command and receiving, discipline yielding to the ability to take initiative, to evade the way they would do later, when playing, throwing popcorn at each other, and still later, chairs, in front of their 90th Air Squadron banner, the oldest in the nation, founded in 1922, "pair-o-dice" their motto and their seal; she drinks gasoline, she force feeds it like sipping Starbucks up through a straw to produce 58,000 pounds of thrust weight compared to 40,000 pounds fully loaded, allowing her to take off straight up and reach Mach 1.5 in a few seconds on the way to Mach 2, everything recorded, everything stored in order to relive it, to evaluate it, to slow her down long enough to admire her curves and angles, her beauty, her radar and electronics allowing her to track and fire BVR, Beyond Visual Range, with your finger on the trigger allowing you to unleash more bombs and missiles and rockets and firepower and raining hailing destruction, each one of the pilots packing a literal pair-o-dice in their jumpsuits, children's images and talismans used for adults who maintained almost a childlike innocence toward what they were doing, testing the other side daily and being tested by them daily, knocking on the door, knowing, trying the latch on the window, hoping to find something left unlocked with the nozzles of the engines burning so hot as to glow, they pass heat, they possess heat, they're intensely masculine and at the same time intensely feminine, everywhere there was something to do with immense tension, seeing someone, speaking with someone, flirting with someone, touching someone, connecting with someone, in their youth around here many of them had hunted and shot squirrels, dove, quail, small animals, then bigger ones before facing down the bear and then, to get away, switching on the afterburners, which essentially involves shooting gasoline out the back and then lighting it, really putting the hammer down to the floor; at all hours of the day and night, on weekends and holidays, you kept coming back that way such that I could only imagine what it must have meant to you, done to you, for you while you were piloting them through the steep vertical climbs, the g-forces, the noise and power and peril and inventedness, the euphemisms used for kill, the euphemisms for defending a country and interdicting others from showering fiery mortality down on the home nation from the stratosphere, you would never be the same, you would never again be totally pinned down to this earth, fish swimming under the surface of the sea, when the last big one hit 79 million years ago, connecting to the television sets running and the billiard tables and their short haircuts and the way they would mill around and leave the door wide open and let the blistering cold in and they wouldn't even notice

Ymir

At 4:30 p.m. on November 27, with the day, the month, the year, the decade, the century, the millennium winding down, I don't know why I looked out the shuttle window just then. I knew we were descending, on final into Logan. I had done it hundreds of times before and have the miles to prove it. But there was a shock, an astonishment at seeing this, what I saw.

There was totally nothing out the window. It was waning daylight, it was darkening, we were nowhere, no where, there was no scale, there was no bubble in the carpenter's level. It was blue, maybe it was already water we were in—the hues said we were diving, submerging. The opacity, the nothingness, the stillness, the mist, the glassine surface of the water, the suspension, the suspense, that hanging in the air—there was something about the way the water came slowly out of the indistinctness, the blue, the lights, the fog. I was a fourteen-year-old boy in the crow's nest of a brigantine bark, passing Brewster Island and Hog Island and the Boston Light, homebound to Milk Street.

It was skim milk blue, pillow blue, delphinium blue, pajama blue, wallpaper blue, stucco blue, sapphire blue, fresco blue, periwinkle blue, Adriatic blue, dress-shirt blue, magic marker blue, eyeshadow blue, cornflower blue, blue-veined blue on your wrists and your forehead.

The little islands, so often glimpsed in bandwidth-spanning daylight, were stones in the pathway, archipelagoes of cloud.

The arrival had an unmistakable feeling of finishing something, of moving on. Yet there was also an emerging, a casting off of lines from spars. This was landfall, and this landing was reaching a landing, but there was also a ruffling of sail, an unfurling, an embarkation.

There was a whole hypertext markup language to this instant. You could point and click and go backward and forward. You clicked on it and you were looking at an aquarium in Finland.

It came up to me, you came up to me, in that flowing, floating, glühwein gloaming, that twinking, twinkling, tinkling, tintinnabulating twilight.

At that moment when nothing was tangible, you were most tangible, your voice was already on a voicemail, recorded, stored, and not yet delivered, slurring your words, saying fast that you missed me and you wanted to speak with me so that you at your end, and I at mine, rewound the message and played it again to make sure it was heard right. Later, looking into your eyes and looking away, some of the meanings came back. Maybe that approach was a dream, maybe the air was a bridge, or the frame-frozen frieze of the scene was a sixteen-lane interstate after midnight.

We were moving at 150 miles per hour, but everything was slow, slow

Setebos

This limnology wants to put you right there with me on the quai, or on a high balcony in the Montreux Palace Hotel overlooking the water, or rolling over and sensing the dark presence of Lake Geneva in the middle of the night. The shoreline, and the streets, and the structures, are no doubt still there, just as I left them, because they never changed in all those visits, except for the tiny variations between November and March. November was always like 11:30 at night, with the specific heat of that huge body of water like a sleeping someone giving off candlepower, warming you through dream and linen. March was different, like bolting wide awake a minute or two before your alarm was set to go off, and being proud of yourself for being ready so acutely to burgeon, blossom, and burst.

Nothing ever changed—the high-season tour boat schedules, the menus behind the tiny glass frames, the garden furniture, the curtains. The little plazas and kiosks and public spaces in Montreux combined North Sea resort shyness with Côte d'Azur exhibitionism. The boats, the pellucid clarity of the water, the nakedness of the undersides of the fish and waterfowl, the distant smell of smoke, made you sense the unmistakable presence of Nabokov. When you dipped your wrists in that water, you felt his words, his index cards, his walks on the French side above Evian, the butterfly net.

The vine-by-vine and bunch-by-bunch cultivation of the vineyards, and the carefully tended plants in the planters all along the shore, said this is wealth married to discipline. In their variety and their tropicality, the plants never failed to stupefy. You knew that come August, Montreux was going to be vogueing and posing as Lugano, or Como, or Positano.

I was so proud of how I paid attention to the plants, racing along with no one, with the mechanical pencil plumb out of lead. The emptiness of the lake was always on the verge of sound, but finally without the capacity for sound, like standing inside a huge bell without a clapper. In that lapping, teary quiet, I said their names, squeezing the frosty berries under the nose between thumb and forefinger—juniper, ginevra, Genève, Geneva.

The enormous reservoir of potential energy in the lake, storing the water off the high Alps before releasing it down the slicing, sluicing, schussing stairs to the mighty Rhône, always made me push the envelope hard, and sweat and pound hearts like a hummingbird. That madder lake margin was possessed of a whole fractal geometry that was brimming with surface tension and discovery. You kept rounding the bends, expecting to find a straight shot to the Château de Chillon, but it was always still out there over the water, with inlets and Peano curves and coves between you and ahead of you, and you were left relentlessly climbing solo switchback trails to Bridalveil Falls in Yosemite.

It used to be a big deal to finally make it to the castle, but after a time, I began to go farther from there, running right next to the railroad tracks, where the steel, the path, and the edge all went in parallel. In three languages, the initials on the cars said SBB/CFF/FFS. The trains were swift and silent. You resolved to keep count, but you could not stop forgetting about them, and all of a sudden, they would be upon you from either direction, with that deep-throated tugging locomotive power, and the diaphanous slipstream, and the chanting wires overhead, closing with urgency through the Simplon to Italy.

Some years ago, up the hillside from the lake, the Swiss built these soaring twin-span highways, graceful concrete pavanes dancing high in the air. It was thrilling to watch the European lorries driving in the sky, and race them from far away. The roads were built to last for centuries, but they still seemed to hold danger, because they were so delicate looking, and lacy, and white, and the road surface was as much as a humdred meters off the ground. They looked so stable, and at the same time, so precarious. Every fraught minute, something felt bound to give way.

All that Caspar David Friedrich stillness, the mysticism, the something supernatural, the first snow sliding into its fir coat, knew how to reach inside you and complete you. You always felt that the Dents du Midi mountains on the other side, the hotels, the lake, were referents not to themselves, but to some other time, to whist players in a closed carriage with huge steamer trunks on a train from Moscow for a three-month stay, or to signing treaties in the ballroom regulating naval passage through the Dardanelles.

On each of those runs, the serenity, the scenery, the light, the gasping picturesque quality of it all, looked like you looking at yourself alone in the mirror, or written on creamy vellum in Mount Blanc onyx. It never left you, like the teeth marks on a hand from the dog bite, or the stain on an upper arm from the jellyfish sting, months, years later in the shower

Hi'iaka

The USS America stretched 300 feet to the highest antenna from that point where the keel was first laid down. It measured 1047 feet from bow to stern, and 252 feet in extreme breadth at the center-line. It was so big and tall and impossibly overpowering. But from the air, it was nothing, a tiny RAM chip in the middle of a circuit board, maybe even just a line etched onto the chip. It was not yet your home, your cradle, your coffee, your pillow, your room, your closed space. The allusions and connections to Melville were everywhere, in the nineteen-and-a-half-year average age of the sailors, in the pelagic blue waters, in those five percent blowing foaming Aphrodite whitecaps.

All of them were in their worlds. They were domed in their own private airspace under helmets and earmuff headsets. They were all watching: the pilots, the weapons handlers, the electronic technicians, the deck crew, the air boss and the mini boss, the traffic controllers, the refuelers, the cook, the captain.

They watched each one live on the big radar screens. High inside every room's corner, there was a TV monitor, and somehow, people always sensed when to look up right at the key moment, when the straining holdback bar was released, or when the little light on the plane's underbelly—its optical speed indicator—was flickering down and to the left of the crosshairs' crossroads. Each takeoff and landing was recorded, on videotape, on chalkboards and clipboards, on spectral see-through grids filled in from behind with letters written backwards, on ten-inch spinning reels of tape drives and backup mounts.

Regardless of how many times they had happened before, each of these events had its own strong, individual, shattering identity. Each one held the possibility for error, for miscalculation, for mind wandering, for turning out not right, for burning, drowning, ejection, emergency. It made them screw their focus in tight. It made them pay attention. It made them check and recheck. They never started air operations before they had launched helos out ahead over the water, just in case.

They kept coming back to you, at first during the forty-five seconds between the shots and the traps, and then inside, at 3:00 a.m. or 3:00 p.m.. The stream of those intense, frozen framings rode the crest of the sinuous swell. They rode on their own Fourier-rebuilt sine waves. They were remarkable for the sheer number of those halting stop-times that were arresting but ultimately were about everything but stop. No matter where you were later, the bundles of concentration you had wrapped up so tightly tended to burst loose on you, made everything stand still in a marching parade of pico-seconds, with sharp light shaping shadow and angles snapping themselves to attention.

Maybe it was because of the everpresent high stakes on a microscale, in spite of the thousands of repetitions on a macroscale. Maybe it was the speed and relentless progression of events. Every single one of those moments said that even though there is no satin here, I am with child. My time has come. I am now going to give birth. I am suspended in an instant of hanging, at the top of the swing's glide path. I am just about to blurt out the marginal proof to Fermat's last theorem. I am going to climb down this side of the valley and race up the other slope. I aim to lick those nautical miles and roll them over and dump them out into your lap again.

They made you flash on everything and nothing, while sliding your hands down the steep slick stair rail, while turning on a faucet, while lifting a cup to your lips, while looking back at the whitecaps

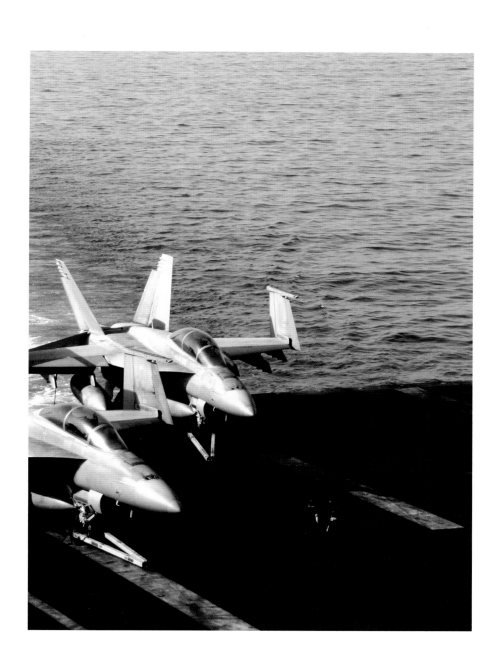

AMALTHEA

That night, when I was working, it hit me, not just how much I used to run there, the miles upon miles in snow and heat, the realization now, that all those times then, I was being drawn and attracted and addicted to something when running there, the town names, the Dutch gambrel roofs, the river, the constant repeated coy glimpses of the water, the history, the smells, how there was some kind of force weaving me, lacing me, interlocking me, and now that I know this, how clear it all seems, how much I loved those hours, somehow like the opening measures of "Carmel," lifting me every time I pressed the reset button, watching the sharps and flats and chords blending happiness and melancholy through the little lighted Yamaha window, trying earnestly to capture and connect to the song, and finally, copying and laying down those notes, vowing never to forget the feelings and journeys evoked by those passages, how good it felt racing up the hill to pull the curtain to in the shower afterward, how there was this invisible gravitational tugging, some kind of magnetic field, the ice unlocking, sending the swirling floes downriver, that never-ending newness even in the face of the recognition, the noticing, the taking account, the historical markers, the churches, the high school, the cemetery, the auto body shops and doctors' offices and realtors, the curves never the same, everything trying to say something to me, to speak to me, the arching branches, the slanting, slashing, shivering, quivering light, the quaking leaves all full of xanthan and mango, the shadows, the slurping and gurgling by the shore, some kind of unheard beckoning, the wind, the humidity, the cars, the sounds, all of it, how now how clearly they fit together, like rows of fiber-optic pixels delivering a polychrome message, saying that something was being said, even back then, all the favorite radio stations' songs pouring through, the waves washing over and everywhere present, flooding back, clicking tumblers and shattering sound barriers left and right, that place, that river, maybe it needed going to Cold Spring and bending back to climb Breakneck Ridge, maybe all the wheels had to spin and fly and line up to point out what it was, that spiritual presence, those many times and days and nights when I wasn't there but whatever it was, was there, and it was something, keys and jigsaw pieces and mosaic tiles emerging, all the pulsing and swelling and searching bringing on this unmistakable, unrelenting tendency that was leading me to a place, a conclusion, a spark, a realization: you

PHOEBE

You kept having this sense that it rhymed with something, or wanted to rhyme with something, maybe itself from years earlier, like when you heard her singing at 6:00 p.m. on the radio on a Sunday night, and you were told that the song was twenty years old and you weren't sure whether you had heard it before, but you liked the genre so much that there was a good chance you had, and you so liked her that you adopted it now like crazy to own it so totally and completely now that it began to encroach on back then, to such a degree that you convinced yourself that you had somehow owned it and made it a part of you back then, took the way you were coming to the realization that by learning that widespread spoken language today, you would make yourself eighteen , or twelve, and offer yourself whole new experiences and ruddy fresh anticipating health going forward, you had this sense that you wanted to draw it, and then it would begin to draw you, you wanting to locate that spot you had looked out the train window in Connecticut with George Benson's "Breezin'" playing in the earphones always at just that place, always in the morning slanting light, always with the same emotions you had scattered through here, finally entering here today in all its subtle sepia, its gentle grisaille in the real, or maybe in the already altered Photoshopping of that day and later, science fiction, playing God, it was like a huge blank sheet of paper, beckoning, waiting, all the purity, those unspoiled blendings: of land and sky, shore and sound, distance, closeness, noon waves, water waves, rivulet, cove, creek, lapping, ebbing, flowing, soaking and inundating, the way it teemed with life and nutrients, in constant motion the closer you looked, the wind, the temperature, the waters mirroring the sky, the geese, the colors had drained out of the crosshatched grasses making where you stepped look like hay, and the signs were telling you it was going to be lush in a few weeks, the weaving making a kind of fabric that you could protect yourself with, this stitching, this fitment, the vestments themselves a revetment, curtains, costumes, a stage set and now trains came through one by one, many more than you had expected, you on one of them days earlier seeing this place for what it could be, what you could make it, alongside the lake in Switzerland, the millpond upstate, Japan, the Pacific, knowing what you could do with all this, the nakedness, the margin, the verge, the merge, on the shoulder your vision writing whole books of the Bible, this indescribable unrelenting centering and alignment, the waters and what was the highest they had reached in the past, what they were going to look like this twilight when the rains began in earnest, and later, in the dark with it really pouring, you knew everything was going to be drenched, soaked, looking for a channel and a release place somewhere, anywhere, everywhere, all this bringing some kind of hazy comprehension that came up to you out of the bath, out of a solution like a tangerine-hued carp in the pond that you could have sworn never happened, the blink of an eye, it was all just an image, a palimpsest rubbed off the bas-relief of the triumphal arch where ten maybe twelve streets converged at the point and the moment of carrying, placing, arranging, decision: the heath, the moon, the marine air, the salt smells, the filtering and winnowing and filling-in asserting themselves in such a way that every para-graph carried weight, every sentence, phrases, words, punctuation making you go back and reread, rewrite, search through the past to find just the right place to place in this place

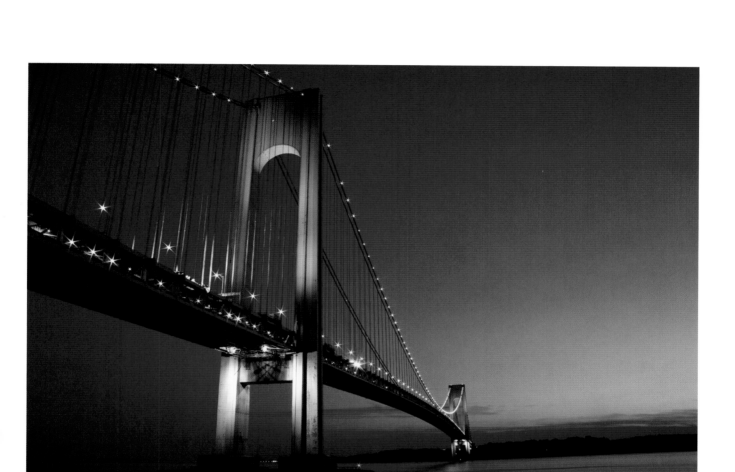

PHOBOS

Let the same mind be in you now that was in you on that day when we put ourselves out amidst all the other vessels, making our own little possessed world in the center of wanting, expecting, wishing for the leaves to grow out even more, stretching and straining to reach full size, swelling with summer, cinematic, poetic unfolding, this sense that sometimes the things most worth describing were those just out of reach of description, those we weren't even sure we could identify when we began trying, this fractalization, this scaling and subscaling of discovery, ever diminishing, ever expanding, urban and rural life, the migration of birds, the shape and armature of you, the boat, the water's edge, the shifting cloud formations all coming together in some sort of Grand Junction beyond time, pushing and pulling, stroking, rowing, searching for meaning and connectivity backward and forward, picture-takings of snow, ruddy cheeks and snowballs arcing through the air, the pellucid high-bouncing sunrays, so spread open to nature that you could feel each blade of grass pressing up against you, gradual realization that those mini-anchorages, the blending margins of branch and water, that day was but one in a whole formation of sequencing and rhyming and naming and referencing, laden to the brim with revelation and understanding as you delicately rotated the lense with your fingers to select, sharpen, signify water in lakes everywhere, in creeks and rivers and swimming holes and in us, crystals readypoised to assume shapestructure and pose, sitting straight while the oars were motionless, to glide, and drift, and homify all this into a sheltering, shimmering, solacing place of loving oneness and warmth

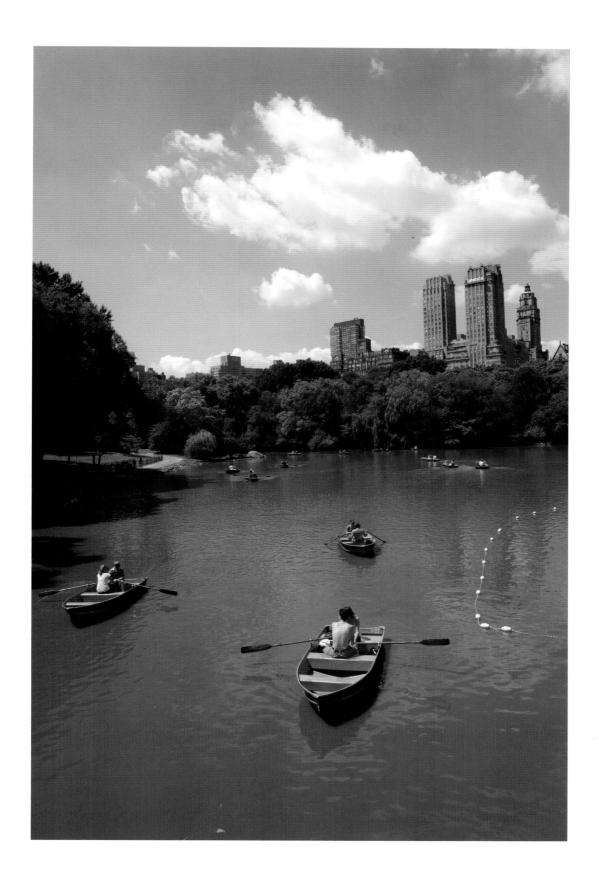

PANDORA

Why did you have to go and get that goat? Why couldn't it have been me? Why do I pen these letters up on paper and wait for it to be you who opens the floodgates? Don't you feel anything? Don't you ever talk to me? I know I'm not the you to you that I want you to be to me; I couldn't be, or else you wouldn't hold back and hold out and hold on for so long.

Don't you dare drop your guard, even for thirty seconds—I don't want to know about it and then have it pulled back. I'd rather you never see how I would see you, with the veil lifted, and how you would appear. Of course, I'm not going to send you this, or any of the others, because they would frighten you and hurt me to be entertaining you so far down that one-way street with none of those inked uncials cascading down over your own watermark.

I know I couldn't feel this way, about you or anyone, if my senses didn't tell me you cared as much as you do. I'm sad the Valentine's Day gifts have been massacred, but I'm just as glad too, because it would have intemperately greenhoused my earth and raised the level of all seven seas just enough to lap but not inundate.

Both Eugene Onegin and Tatyana would have been better off never to have written nor read their letters, for all the eternal heartbreak that came barreling in their train—haven't you asked yourself what happened to me, to your and my inspiration and motivation and encouragement?

Tell me your eve's eye hasn't marveled at those towering backlit cumulonimbus clouds, over the ridge, over the river. Your true and abiding affection goes out to you and then comes home right now, in this everywhere hour.

Don't you call me when you decide you want to ignite the engines. You know that all the ammonium perchlorate is there, waiting to combine with the aluminum, blow off the restraining bolts and provide millions of pounds of thrust, enough to break the streaking chains of gravity, but nothing will happen without your colorful reagent.

At some point, all the battlements will have been built, and the guns will have been mounted in place, and trained outward in your direction, and there will be no way left to me, except overland, through impossibly shaded and reticulate trails in the rainforest, down the spine of the Johor peninsula

PROTEUS

The way that place kept pushing in from the edges, not giving up, impinging and finding a special path through, whenever the days began to shorten, and the leaves started to change, and the winds picked up and people began to walk more briskly, turning inward, returning there, looking everywhere for something, maybe that something was in fact a someone, and weeks, months later, that someone turned out to be you, you in a flashcamera image in a group standing beside the rocketcar, you with him and her and me and them with all that wroughtness in the surround, it began to whisper and hint and foretell and foreshadow that the guardian angel might have been you in a more complete guise, but in the light of now, that place was unmistakably you, you in the shopwindows and along the tiny streets and adorning the facades of all the multihued belle époque buildings with the windowboxes and brick and stucco and limestone sills and lintels, and the quoining, connecting to the parks and the concerthall where the chamber works debuted by candlelight on brisk bright afternoons just like this one, looking for what seems now not to have been anyone but this you, seeking you in the fragrant chocolatier, crossing and recrossing the narrow little bridges over the limpid Ljubljanica waters running through the middle of town mixing with the lanes and side-alleys and art galleries and the chestnut vendors playing the accordion night after night never leaving this place because you were in it, you climbing the steep way up to the castle through the scented appleyards and doubling, redoubling the switchback trail to ascend, looking down on the tile roofs in the golden coming of the leaves to match the rays of that slanting day, standing on the parapet and basking in it, the elation, the compactness, the neatness, the pealing churchbells, but before dreaming later that night, it suddenly vortexed in on me, the fact that it could upon looking back have only been you, now tenderly, softly, silently individually coating me with the year's first fragile flakes of snow

LYSITHEA

In the dream that kept coming back over and over, we often found ourselves standing in front of this huge map that totally filled up a wall where it could capture the light and make the oceans and islands and archipelagoes come to life, the topography of the deserts and savannahs and mountain ranges vivid and visible like never before, barrier reefs and seamounts swimming in the swirling blue currents and you and I would take great delight in your asking me where and what and when and how, and in the dream, I was so hyperaware of how it made me have no other feeling than to want so dearly to go there, to be there, to live there, to make and create things there with you, to immerse ourselves in its vastness and feel wave after wave of Atlantics flow over us, whole prairie provinces swallowed up in those skies, the bright hues of the earth, the lushness of the dripping green leaves making oxygen for the world, the names and shapes and colors of the fruits that we had to be shown how to eat, like slicing salmon and choosing whether to use fork or spoon, the plants and botanical diversity, whole species that we had never encountered before, asking ourselves what these things did to shape the peoples' personalities, their attitudes, the sunlight providing two orbital trips per year to the rest of the planet's one, knowing that the rain was falling somewhere, that oxygen was rising out of the forest canopy, the fish were growing, the Fernando de Noronha islands off the shore staying so pristine that we had to secure a permit to visit them, mixing road building, crop planting and harvesting, the way planes would take off and land, their love of rivers so evident by the way they would react when you happened to know where they were and pronounced them correctly, their lyrics and melodies, the instruments, their feelings and emotions that you thought were impossible to put into words but they had found a way, playing and replaying them, their dances and costumes and plumage suddenly giving way to recurring surprise at how the plasma laser could slice through the air, then through the water, sparking all cobalt and yellow and orange hissing and bubbling and steaming as it shot through several inches of high-strength steel following emailed instructions showing precisely where to line up the first point and let it go from there; there is no question that their pride and the way they so lavishly reveled in attaching themselves to and identifying with a place, somewhere, their football teams and their food and traditions, maybe this was what kept pushing the two of us back to the map in the dream, how a person could move away from somewhere, but they had gotten so identified with the place where they had lived that they took part of it with them to their new place, and it did not stop there—someone who moved into the old place where the first person had lived took on some of the original person's place in your mind, some kind of place twins, or place siblings, if not place cousins, the way they spoke their language blew away all the other languages and dialects and speech patterns in the world, the nasals, the teeth, the lips and tongue and throat and how they could draw out a syllable to twice its length or flourishify the endings of words so that you repeated the word many times in your mind, long after they had moved on, and you were struck by the forwardness, the fondness, the friendliness, their allegria making every single meeting end up as a party, you wanting their language to be yours, their literature your literature, poems and magazines, romance novels and TV serials, the words and accents and constructions owning you so pervasively that one of the things that came back so relentlessly in the dream and then in thinking about the dream and dreams and dream integration was this nostalgia, this asking, this marveling at the men's and women's names, and the parks and streets and boulevards that carried their names, wishing and wondering and role projectioning to where you finally became able to own and hearken back to more than one past, your eyes roaming all over that wall map, all the places and times and experiences generating dreams like no other cartography

TETHYS

The sheer quantity of it, the pelting, quenching, gusting gushing evacuating rain and the way it just continued to pour in at full blast, swelling those short rivers under the white cast-iron bridges, cleaning the streets and washing down the aluminum, the marble, the carnelian, watering the palms and the orchids, the oncidium and cymbidium and bougainvillea and oleander cascading over the pots beside the roadways, it made you think of the lightning shooting down from the sky the night before, not all jagged and branching and then gone, but always in a straight line, a printed circuit from sky to land, and the way it would freeze in that position for a long time, it seemed like several seconds maybe, and just hold there in that pose until you thought it would never stop, waiting to speak, the way the thunderbolts dove out of the heavens to hit the Kinta River Valley tin deposits beneath the surface up the Johor Peninsula again and again and you asked yourself just how many times per year this went on, and what effect it had on the people who had felt this sense of peril and fragility from day one and had resolved to run fast, to draw things, to organize and coexist and build the highways to double if necessary as airstrips that would allow fighter jets to scramble and climb swiftly up into the relentless, unceasing cloudbursts of drops irrigating and laving the tile roofs, the chophouses, the swirling roads and languages, all those ships lying at anchor waiting, sort of like saying grace before a meal, water running over the decks and the wheelhouses and some sort of fractalization going on with the umbel spread of trees over the roads, the way the apartment blocks were arranged, the roar of the fountains, the succession of islands each having its own peninsula, smaller and smaller replicas like the stamp on a postcard having ever tinier mise en abyme pictures of itself, as it got mailed to buildings from the colonial era that were now fitted with fiber-optic and multiple shower heads spewing spray everywhere as the rains hit the roof and the windows slantwise, clouds reforming to complete the circle, the most romantic letter ever mailed from here, ever received here, the most improbable parcel, maybe it was an elephant, or the biggest Burmese ruby ever mined, something that came through here to alter the lives of millions, or possibly a few lines describing what it might be like in a future century, foretelling so accurately and honestly that no one believed it could have a chance of coming true in such blinding heat and humidity, no one could fathom the unceasing downpours like this one that so soaked and irrigated everything to later boil off in the blinding sun into these epic stark white cumulonimbus structures in the heavens

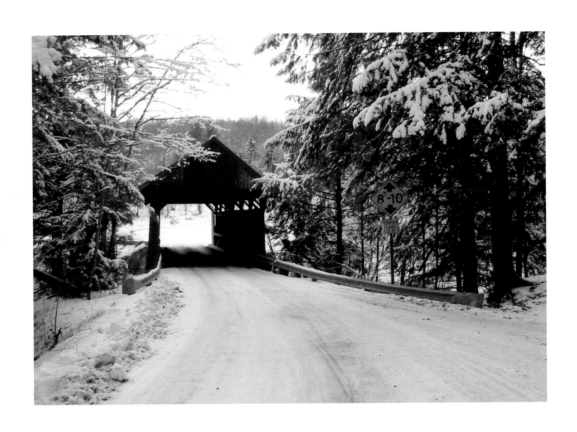

MAB

Come on now, you've never arisen and had me greet you, switched on, fresh in the morning? You've never looked through a window sash and wished and thought? You've never carefully folded the dishtowel and hung it up to dry and almost shouted from lack and wanting and loneliness for breathing me? Or, in moments of intense artistic surfeit and overflowing your chambered volute, you haven't secretly and reluctantly moved me into the range finder, pushing the buttons on the car radio, or letting it scan the particular waves and seek and meet and home and come back, half voluntarily, half involuntarily, to me?

You mean you've never once felt me in the summer heat, you've never hugged some bundle of winter down and wanted it to be me, me striding across the covered bridge to hug you, and suddenly you were the down, the down quilt or jacket or comforter or pillow, the Cuddledown duvet and I was you embracing you in all manner of dreaming?

Has it ever shocked and surprised you, how tangible and detailed I was in the dream, how you in the dream paid the kind of attention to components and textures and lucid juxtapositions that you've heard me do in all the bright reflected life of each paginating day? And all the little things that I'm now attached to in your mind, books and words and stories, buildings and countries and eras, theories and scientific discoveries, Olympic games and space launchings and mighty oceans and rivers, they don't make you consider and reflect and marvel?

And what about the runic signs of certain animals, and food, and even the sinuous vagaries of tomorrow's newfound weather? Could it be something like a shared town name that's found in each of the states of New England, all these multilevel kincourse connections that crop up like shimmering diamonds of Bach music played on an organ with pipes of kimberlite?

How can you keep it leashed and lashed and contained and controlled?

Has it ever made you want to drop everything and beg the nib of your pen to describe this feeling?

SELENE

How you were lying there and trying to get a handle on just what it was you were trying to get across, and in that quiet rotation and mulling over, you resolved to concentrate on the impossibility of describing all those crossings, what they all shared and what it was that made each one so different from the next; perhaps near the top of the list was this whole tossing of time up into the air and trying to catch the fragments that when you left had fit so well together, and now were all askew and akimbo, emerging from midday suddenly into Vespers, Compline even, the images quietly following after you like cats, purring and feral and crying for attention yet shy about accepting it, or maybe being reminded, chastisingly perhaps, that you had sworn you would give conscious thought every so often to the parallel, mirror-inverse imagery and activity and daily living that was playing out here, the labor, the love, the emotions, the food and climbing onto moving escalators, sipping soy milk, the street signs, the pedestrian flyovers and bridges, welders' sparks and scaffolding and cranes whirling overhead, the steepness and the footpaths and the vegetation, you had said to yourself, promised yourself, that you would occasionally call to mind, and maybe the reason it never really played out this way was the fact that if it would have happened, it and you would have quickly begun to spiral out of control, you all day long thinking back to putting on your boots, or reaching for the light switch, or never letting go of setting the clock back or forward in the fall or spring; the wiredness late at night winding you up, maybe it was the stacking and the concentration, the blazing 24/7 energy making you wonder whether you could exist on twenty minutes of sleep per day, it was all about these fundamental mathematical constants, scientific postulates, volume, quantity, work, all the stuff contributing to this astonishing, profound sense of distance and measurement and missing you, simultaneously drawing you closer to me than ever before, ever possible, ever imagined, so near as to be in miniature, so bounded and always imagining what it had looked like a hundred years earlier and sensing that thought begin to press in on you as you swam feverishly against the current and wondered when there could be a period of stasis with things on hold for a little while, the writing and the characters drawing you onward and throwing you inward at the same time

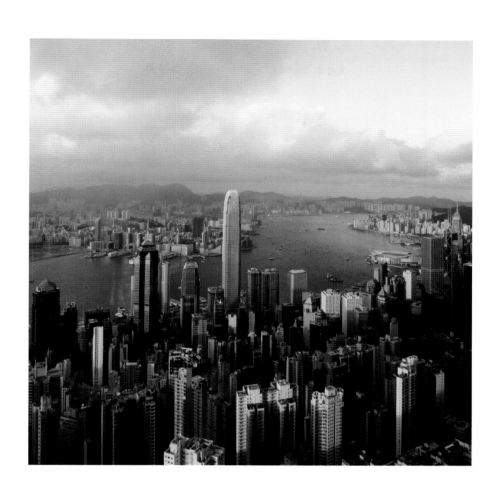

LINUS

It all happened in an instant. He was undeniably handsome and shirtless, with a sculpted pectoral torso of teak, and he was wearing dreadlocks. At first it was unclear what he was telling the Ellis Island ferry crowd on the Battery quai to do. In groups of two or threes, the people moved aside, and cleared a long, straight space of twenty, then forty, then sixty, and then maybe eighty yards or more.

He appeared to be yelling to someone at the other end of the lane. He kept yelling in the hot sun. The crowd got quieter and quieter. There was a dramatic poised pause, just as when a 747-SP finally wheels into position in its slot on the runway, visibly drooping with enough aviation fuel to fly the longest nonstop scheduled run in the world, from Newark to Singapore, eighteen hours in the air.

And then here it all went. He sprinted 20 yards between the hushed faces, and then began to do these gymnastic flips. In that instant, it began to become clear: that he had probably started these dolphin-porpoising flips way too early up the chute, if that was all there was to be. But then, as he kept doing these huge, open, continuing Olympic revolutions, like the inexorable day-and-night flow of a waterfall, all that was intended to be began simultaneously to tighten, and then rapidly, to expand and capture breath and space.

At the forty-yard mark, the crowd began to speculate that the improbability and worth of this feat was going to derive from the number of the jumps and the hugely physical length of the entire set. He just kept revolving and rotating and spinning, like the Pratt & Whitney jet engines on that flight, and going down the allée, his hands touching the asphalt, and then his feet, hands, feet, his body, his torso, his head, the religious scapula around his neck, his bent knees centering gravity, with the shoes and swinging dreadlocks stop-flashing and freezing like the incomprehensible lap mode on a digital watch running free.

The opening for the crowd zipped up behind him as he raced past sixty yards, still spinning and jumping, going on, and on, past all limits of dizziness and belief and human strength.

And then suddenly everything flipped upside down, from there being absolutely no way he could make it, to the growing possibility and hope and anticipation that it was in fact going to happen—longer, more consecutive flips than ever before in all of human life.

The people took half-breaths, then quarter-breaths, and then faster, eighths, sixteenths. They drew up so tight that they stopped breathing altogether. The last fifteen yards seemed simultaneously to be the quickest and the slowest part of the whole journey. For the final two jumps, he seemed to flip in slow motion, and at the same time, there were all these flywheel-spinning, flashcube images of what had just happened.

He stood rooted to his final landing place with his arms outstretched, smiling, dreadlocks hanging, barely breathing hard. The crowd burst into applause and weeping. People could not hold back the tears, out of shared joy and some kind of couvade of all the work and practice and pain that had taken him across a huge ocean to an unencountered nation of brashness and physical exertion

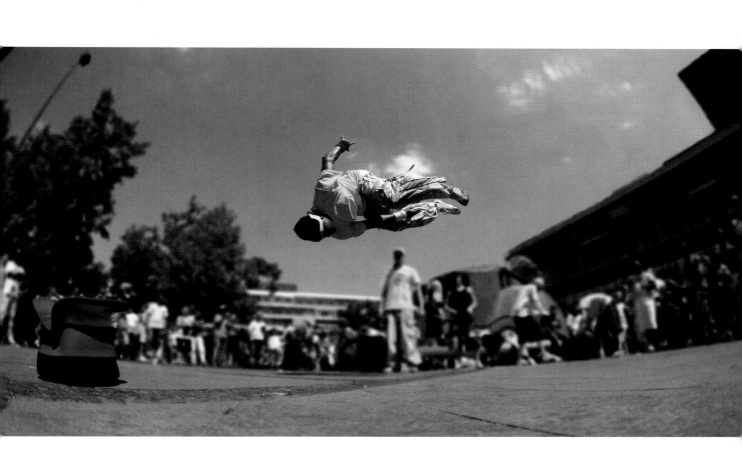

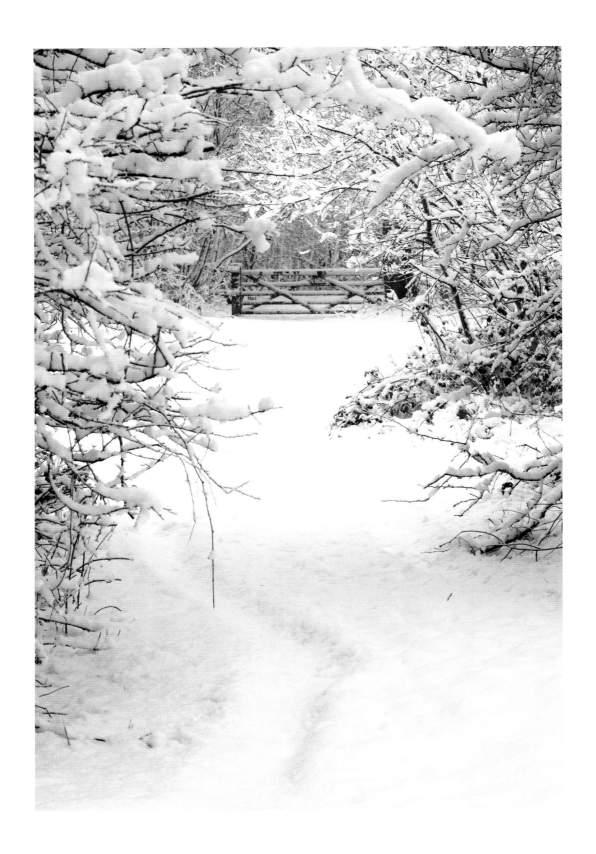

TITANIA

There was this sense of relief and fulfillment upon our arrival, a powerful feeling of accomplishment that took your breath away, not unlike the knowledge that a piece of art you had been bound up with and committed to for so long was now complete unto itself, the days and nights of shaping and formation impossible to have otherwise found expression but this way, this now, this here in all its stark whiteness, the fresh powder daubed to the trunks and branches by the wind that blew snow through the night, bringing more in a few hours, the flakes hitting the surface of the river and attracting the carp up from the depths thinking it was food, the coldest winter in decades and at this pace on track to eclipse the all-time single-season record, cotton-puffs taking flight from the trees and floating, hovering unmelted in the air, mixing with the stars as indistinguishable and indissolubly bound together as the limbs of two lovers; the snow seeming to take wing in the cold and trace out these glittering sparkling nocturnal pathways in parallel, copying the birds' wings that flapped and glided through here on their autumnal flyways, one flock followed by another, and another, until it made you wonder just what it was about the electrons flowing in their own navigational systems, the geometry and geology of this place that turned out to be such a magnet for the avian and the nivean, for the curvaceous sinuous river of stars in the heavens that in warm months served as footlights, spotlights, backlights for the nacreous butterflies, the iridescent fireworks in shades of turquoise and garnet, gold and tangerine, lilac and lime bursting above the fragrant puffs of blossom to make you believe that it was actually the propagating powder that was perfuming the air, the same washed air that made a bridge and carried people and light and color over the arching pathway, the solitude and inwardness made by the extreme outwardness of it all, the way that in a huge snow-fall today's time suddenly became yesterday's time, priorities were reordered, things like protection and locomotion and warmth and nourishment assumed primacy, pushing us closer and onward, pilgrims seeking prayerful gratification in the moist coldness of the air itself, arm in arm over the span carrying all the shaded grays and whites of the sky, pondering the swift steepness of the hills on the other side, the gurgling water about to freeze this year, crystals first, then bergy bits, then floes, and then suddenly, nothing but solid night

OBERON

When you stopped to reflect on it later, it was astonishing to think that one of the defining and central characteristics of those towering high peaks, with their arêtes and cirques, the jagged out-croppings, the improbable forces and etchings and thousand-year stresses that had made this place, millions of years closer to the truth, was the sheer volume of water in the middle of everything down below, this huge calm lakey stillness right up next to where things had begun to sheer off and soar, the temperature of the water, its depth, its purity, its permanence imbuing it with some kind of living presence, it was part of something, it was telling you something, it was trying to speak but couldn't, it was shouting up to and down from the slopes and peaks and vertices about some kind of each-dayness, powerful storms and full moons, twenty feet of snow and summer meadows full of alpine gentian, edelweiss, picnic blankets and candlelight and trains and thick slices of rustic bread; there was this immense poignancy and evocativeness competing for your attention, everything presenting itself to you, showing you, you being here, you lying here, you traveling through here, you feeling that here, there was something that could hold without giving way, here you could fall back and make a fortress, a fastness, an unassailable redoubt, you found here something that could stand up to change, here a kind of piercing, intimate certainty, each encounter with this place a highly individualized exchange that derived its eternal permanence from its exclusivity with you, you never ceasing to replay and revisit those valleys in your mind, the helical climbing recursive turns of the track still impossible to comprehend even after they had been diagrammed for you, even after you had started the watch swinging in one direction and seen it gradually, inexorably appear to alter its path as you curved and ascended, more so as you looked out the window and saw the church from three perspectives, you kept refusing to believe that it in fact was the same structure, the light pouring down the green slopes and casting immense shadows made by the pines onto the grass and the slate roofs of the stone houses; you had to come through here on foot, to feel the steepness and the altitude, to smell nature and appreciate distances and hear all that water rushing out to the sea; it made you want to camp out in the huts, and watch the sun rise and set while coming to appreciate how concealed and hidden and remote it all was, how it was island Greek temples and the Pyra-mids and the landing strip that you had to come back to, sleeping, dozing, dreaming in and out of here, you coming through this place in total transience while feeling yourself start to never separate from this place and its placenames on the signs beneath the station-platform light at midnight, you leaving huge pieces of yourself here

NEREID

All this wonder at how the whole country, its history and battles and paintings and woven fabrics could be so concentrated and centered and represented in this one place, millions of people, forests, winding rivers, highways, every church and house linked to these trees and roofs and doorways, tile and stone and wood, the town's name drawing me to its breast and heart as it once had your father, his visit one of the powerful attractions bringing me to this place, somehow, somewhere hoping to chance upon you bending over the fountain in the inner courtyard of the abbey cupping the cool water to rinse your face, or weaving bright swaths of fabric together at a long planked table under the open sky, in every shop I looked for you, tried on jade around your wrist and neck, expecting to find you holding a silver votive light shaped three centuries ago, turning each corner to hasten down cobblestone lanes to seek you out, to kneel in places where I could swear you had genuflected only minutes before, the swishing leaves of the oaks and olives and willows maybe heralding your imminent arrival in the main square, you here, this seat the focal point concentrating your soul and making, this constant ingathering and centering, the two of us coming here to immerse ourselves in the language, forming the letters and words and phrases as children, then teenagers, then adults attempting to do justice to grown-up thoughts and feelings and noticings, these cascading, flowing days and nights, these harmonies of weather and moon, telling myself I had located you in that coffee bar where I know he too must have idled, sipping and poring over the newspapers, where I ordered one cup for us to sip from, passing back and forth, here you most intense of all, engine of caring and drawing near, you so present at the time to come

DIONE

Looking back on it now brings that fascination, that yearning and affinity for Northern Scotland, its highlands and lochs and firths and its shimmering tarns, reflecting the light and weather and sky and the Scottish place-names, on both the mainland and sprinkled through the Hebrides—Fort William and Inverness, Islay and Ramsay and Ronay, the "ay" signifying island; it took going there, to reveal just how much there was not only a discovery, but a rediscovery, a finally finding.

> *How things moved simultaneously so fast—the hours were minutes, the minutes, seconds—and so languorously slow, that everything was in slow motion, and replay; taking one's breath away with its sheer velocity, and hearing one's own quiet, tolling, waiting pulse pulsing in the shower.*

Having dreamt of it for so long, and having imagined its landscape, there was no other choice but to go there, to see and witness and feel, to be in that land and live there, to soak up its sights and sounds and smells and tastes, to see its sun and clouds, to turn to the rain, to climb and descend through hill and dale, in the honeyed fragrances of heather, carrying sprigs of heather to remind and center and ground as to where and who and when, and why, and ultimately how.

> *How things kept coming back, and how you wanted your—no, how you wanted them, on center stage, in vivid detail, a hypersensed sharp focus, and how you also were reluctant to look straight at those revisited images, because, like delicate Renaissance drawings under fine linen covers at the museum, you didn't want to waste or fade or wear or lose track of those vivid tracings, so as to always have them as intensely real as the very first reproducing time you experienced them.*

It was something to drive through that countryside, to wend and find and wind along the curving lanes and the long, straight stretches, the purple and white flowers of broom and canary-yellow gorse lighting the way like lanterns; shadows of puffy clouds drifted across the fields, islands of refuge and calm and soft-spoken reflection and protection along the glistening roadway, a gleaming superhighway of carefully built attainment, so much in the forefront of consciousness, foreground exchanging clothes with background.

> *How the world would from then on look different, painted, served up on a platter heaped high with abundance, and how it still looked the same, only with new attention to detail and nuance and mirrored brightness, new lingering to resolve and notice, new feathers and species and plumage appearing among the branches.*

The only radio station carried a short story, read in a clear and confident voice, about a young man who used to come to the half-open Dutch door of a woman's seaside cottage every day, and stand there, and read to her his writings; the voice, the words, the blending of his story with the narrator's story, the listening and not listening, the drifting in a boat along the stream under the bending boughs of lilac and linden and silvery willow, the stirring excitement of new songs you know you are going to love for all time after hearing but a few measures, and the musical elements underneath that connected you with this song today and to others, the carrying of meaning and clairvoyance through attention as much as inattention.

> *How life's turning points may not have been identified as such when they happened, but looking back, there were signs that were plain enough to see, riverine networks of connectivity and current-flow in readiness and snow-white veiled, whispering anticipation, boats and trains and planes on their way to somewhere, to a destiny place.*

It was impossible to re-create the short story, trying to fill in the blank spaces, imagining the overflowing pink geraniums in her windowbox, and the marine blue—no, the ice blue, maybe the glacier blue—color of her shutters, shutters that were battened down to keep her front room warm and cozy when the winter storms moved in from the sea, and then the story would reemerge, like the sun climbing higher and higher in the sky in the new weeks of a year, and the story was having an effect, so settling at times, and so unsettling at times, that you occasionally had to stop the car and walk a few miles to cool off, maybe to lie down for a few minutes in a little dell protected from the wind, smelling of peat and whisperflower, warm, cool, cool, warm in a thick cableknit.

> *How there were these soft-focus, indistinct, intimate, intimist, luminous, numinous, showy, snowy images, relentlessly mixing and alternating with all kinds of blazing wonders that were blinding in their recurrent brightness, standing out like placid turquoise waters against the boiling dark pelagic swell, teeming and blinking along the razor edges of light and shadow, the shiny green leaves sending back solar messages of line and meridian.*

And always, the blending of land and coast and shore, the bringing of Gulf Stream warmth falling as mist, and showers, and tears, and periodic drenchings that sometimes seemed to lose all control, the substitution and transference and position-swagging, the feeling of driving on the sea, floating on the land, wading thigh-deep through all manner of rushing and blending.

> *How these things inspired you to describe and yet how they tied your tongue; how they inspired you to speak and write, how they at times left you utterly speechless.*

There was this eternal, unceasing pushing onward, pushing northward and westward, like a salmon racing upstream to spawn, racing toward the little ferry crossing at the Kyle of Lochalsh, drawn onward by the winged, fleeting Isle of Skye.

> *How there was this amazing closeness and recognition, amazing candor and respect, amazing creation and recreation, amazing patience and urgency, amazing agreement and variety, whole new species of flora and fauna of support and comprehension, candles slowly dripping their molten beeswax onto what had now become blizzard proportions, each drop still carrying an inner golden flameglow as it spilled over the edge and rolled slowly down, piling up at the very end, like icicles heading south under the eves.*

Then, and in this instant too, the shafts of light would suddenly penetrate the clouds, and throw meadows, and fields, and houses, drenched and blanched in all that illumination, into these religious spotlights of abundant, proud disclosure for a few gilding minutes at a time, hung on tree branches like Christmas ornaments, demarcating chapters in ancient books, giving up signs, and directions, walking across broad plazas in distant countries; they brought far near, and showed you the world, first through a telescope and afterward, under a microscope; they looped and glued together the alpha and omega, you heard again and again the words you had whispered to yourself so that you could wear the robes of arrival; crisscrossing streets making unusual patterns and climbing to sunlit uplands, harboring and mooring the role of music and what it meant and means, the appreciation of place and time and word and prayerful thanksgiving at all this fullness and wholeness and wellness

> *How everything—the pouring rain, the rising sun, the moon and stars, the temperature, was filtered through and reflective of these thoughts and feelings and experiences, and how those same thoughts often left you staring, while others watched, you in your own world, breathing breath; how strength was gained, and how multiples of strength were annealed and forged in the Damascene foundries; how the days were dreams, and the nights were a solstice noon*

MIRANDA

Maybe this was the way it was intended for you to experience this country, from high off the ground, hanging in harness and sliding along that shiny reticulate system of wires on pulleys with light blue fingerless leather gloves to help at those heights, fifty feet off the ground and, when crossing the deep lush ravines, with vertical drops of a couple of hundred feet or more; for this network of ladders and ropes and cables, the elevated platforms fixed way up on the tree trunks, the swish and swoosh of the glistening leaves and fronds and branches, the otherworldliness, the shafts of sunlight gushing down through the forest like warm spray from a showerhead, the feeling that it could not grow this way, and remain this green, and be all animate and interconnected and sheltering, without huge quantities of rainfall, and the respiring, replenishing lungs of the O_2-CO_2 interchange, the saps and nutrients soaking in from the soil and the air to flow and rise and fall, here, here you were and are present, your love, your life, your deep nature-empathy, some kind of blanketing, warm, humid, moist fertile aliveness in the remotest jungle canopy, the springiness and tension and dizzying vertiginous danger at distances and circumstances that if you stopped to think about them, would frighten you into losing your footgrip and confidence and your ability to stand and perch and traverse where only birds and scampering creatures were meant to dwell; you so unequivocally and indelibly in this place, your being, your soul, your strength and fondness and resolve, your quickness and wit and readiness, your hand, your eye, your reincarnating gifts, the way the streams and clouds and nocturnal moonpaths all intersected and mixed and intercoursed and ran together with one another, with you in this junction place; it began to dawn on you and infuse you like apricot tea pervading the cup, steeped one minute, five minutes; for here never ceased confirming a million yous, this flashing realization everywhere of your telling, that all this was inside you: attention, suspense, suspension, Photoshopping

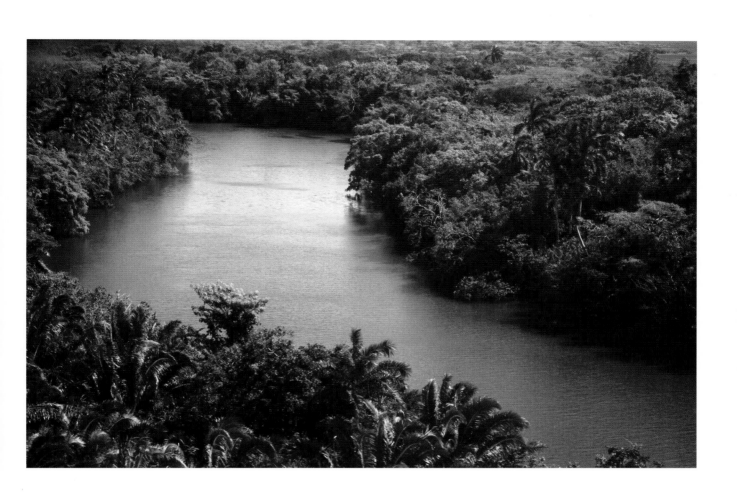

MIMAS

That place somehow always also our place, one of our dwellings to such a degree that it had a homey, welcoming feel to it, the maculated tree trunks, the layering branches and leafiness like cloth sewn into clothing, then wearability coming upon you waiting there in the corner, the table set and little surprises set out; it became this big, natural annual clock and you could not only tell what time it was, you could actually perceive the minute hand advancing in the angulation of the light, the birds chirping and fluttering, the fresh begonias, hosta, cleome, the ageratum an hour hand along the borders, the background noises, the people, the workers watching from high up, ice cubes floating in iced coffee with milk, remembered things that suddenly leapt forth from the mind, a whole architecture of girders, cranes, winches pulling cables, massive hooks lifting beams and sheets of glass, the entire process essentially one of interchange: of the day, of paths to reach there, what you'd read, or made, or heard, or seen, these little stones, pebbles beneath the feet, sitting and inching forward to listen, to hear, to understand, sipped at times, swallowed occasionally in long flowing gulps at moments of great thirstiness, shone out like a huge map that you can unfold and simply by touching, zoom in or zoom out on and locate streets, and specific buildings, and waterways and rail lines ascending up out of the ground, over bridges, and right back down again to arrive at the station stops of your making, marshaling the power of the beloved, harnessing it, spraying it aloft in the sky, seasons, places, times, feelings in harmony and blessing and goodness, hearkening back to that spot, how it attracted seed like a plowed field to render harvest, naturally drawn there to pile up boughs of spruce, lying awake and sifting through stars, mercy and righteousness, deliverance, salvation coming down through the ages, hands touching, eyes, elbows, consolation and promise and fulfillment, it had some inner ability to outlast time, it had its own momentum and life, its name meaning creation and rarity and belonging, putting that placepoint in the mouth and on the tongue, the words and impressions counting out the constellations, waiting weeks for the planets to line up just right, low in the sky so that you could see them all lit up and shining right before dawn, taking on an eternal appellation that was hypersharp unto itself, indicating something, maybe breath, nostrils, shaping wood and water, waving grasses in magic fashioning, the scenography making sense, beaming up with astonishing facility to fashion advanced technology out of rudimentary elements, a simple reed able to span continents, grains of sand, salt water's ions, something as almost nothing as the temperature difference between being in the tent and out, or guiding magnetic charge along breezeways, knowing what to do with the space where flame had just been, raindrops, all of it almost shamanism, or animism, and more sophisticated than electron tunneling, quirky quarks in superpositions of states that you could transpose and redirect as easily as snapping your fingers or sipping through a straw, everyone everywhere all at once, poised to shuffle and rearrange, to fashion pillows out of marble, every night at this exact time flying over lakes filled with rains running off the hills into brooks, rivulets, creeks, streams, merging and giving of themselves, ordinances bearing transformative power, ultimately restorative like antioxidants chasing down and embracing free radicals, humans responsible for one another, making a universe of that one tiny corner, floating between sleep and wake and reaching to comprehend the components and how they fit together, knowing what you were looking for, looking for something similar to what you had fashioned by the silvery rays of the moon, finding solace and strength and support in all the vividness and clarity of what it was always becoming: a room, a house, a caravanserai for protection and waking, an inching forward in the direction of the day, wanting never not to be there, filled up with seeking and having

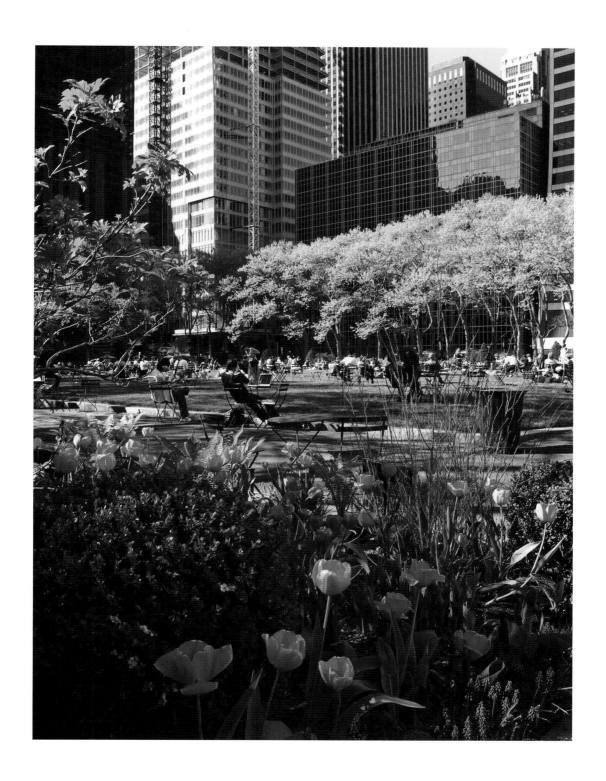

Titan

Dreaming about that day, going to sleep, waking in the middle of the night to read, drifting off again, and meeting the white car and the young sisters, noticing the scent of jasmine, going back for the forgotten passports, having flight after flight canceled, learning later that this happened 80 percent of the time because of the heights and the thin air and the poor visibility between the peaks where the planes were always trying to find their way through and land.

Our own flight vehicle was a metallic ice blue Mitsubishi with orange trim, big new thick-treaded tires, a sunroof, and patterned plush seat covers. Our driver was an experienced hand at this trip, having made it twenty times or more.

We had been told that the drive was truly spectacular, arduous, incredibly sinuous, and that it would take a minimum of eighteen or ninteen hours, so we left, our driver fasting from sunrise to sunset during this time of holy days.

We took many rolls of film from our swift-moving Pajero, and as the day wore on, it began to sink in that this was going to be a trip about nomenclature, about climbing, about time, and light, and bridges, and most of all, about interior and exterior worlds.

The evocative names of these encountered towns were dazzling: Havelian, Abbottabad, Mansehra, Thakot, Pattan, Sazin, Chilas, all along the way to our final place. There were countless other smaller villages, and fleeting pass-throughs, many with marked names, many having no name. They told us that one meant "warm waters." Was it a settlement now? Had it been a settlement once before? Why were the waters warm? Maybe that meant the other waters in these parts were ice-cold foaming tongues of green, rolling off the mountains into the slate gray-brown roiling mysterious waves of the headwaters that were merging and braiding to form the mighty Indus, the spinning Indus, birthing and berthing ancient civilizations at Moenjodaro, far downstream.

These places that we passed with no names at all, just children, and animals, and carefully fenced plots: weren't they worthy of names? What did naming or non-naming imply about these places?

On the Karakoram Highway, we could not find anyone who knew what the word meant. To us, the word Karakoram ("broken black rock") began to assume almost mystical significance, on signposts, in conversation, in abbreviated form as KKH at major forks in the road. KKH became our eternal home. It took on purpose and weight and symbolism. Whatever the origins of these and other names, and their real meaning, each became every bit as grand to us as Himalayas, meaning "house of snow."

We were totally in thrall to names, to these names, never deviating from these names on our way to Chitral, to Swat, to Skardu, leaving behind the other bifurcating branches, each heading off to its own worlds and sunlit pastures and Shangri-Las.

Our journey was also about time, embodied in the passage of time it was taking to cross this difficult, dangerous terrain as fast as possible. It sometimes consumed an hour or more to hug the narrow mountain road and advance six miles, not much swifter than a good runner could cover the same distance. The markers wouldn't go by any faster. We were constantly aware of time, of the time of day, of the time of departure, of the times of prayers, of those little turquoise clock digits with the changing numerals on the dashboard.

We began to consider time not only as expressed in kilometers and miles, but also time expressed in getting from one place to another. Time raced as our four-wheel surged forward through the gears, occasionally making it even to fifth on the rare and eagerly devoured straightaways. Time crawled as we downshifted and braked, steering around deep drop-offs and depressions in the road, dodging washouts, mudslides, boulders, waterfalls, flocks of goats, teams of oxen, mule-driven carts, bicycles, gaily painted Bedford trucks, young men, old men, tollgate crossings, bulldozers, standing pools of water, rushing steams, soldiers, farmers, policemen, shepherds, vendors, a solitary beggar seeking alms on badly crippled legs and a cane.

All of these we passed in due course, noting how their own internal rhythms kept bringing us back to time, to our own repeated references to time, and to the special character of the light that was flooding everywhere.

The light stayed in the background at times and loudly called attention to itself at other times. The diffused bright light of the sun rose over the highway and baked the soil and flowers. The pastel shades of midmorning light filtered through the new green leaves of the darting trees as we watched the farmers gather hay the same way they had for centuries. Fiery fiero light broiled down on us as we stopped to buy dates and oranges and mangoes. The 1:30 light suddenly brought Northern California into hypersharp clarity, as we descended one more little recursively curving hill in the midst of our relentless ascent and came upon a stand of eucalyptus lining a lane that looked like it was in Mill Valley or San Rafael. The early postmeridian light shone straight down the canyon walls with no shadow.

As the afternoon wore on, all kinds of Newtonian light poured down those steep drops, of two thousand, then three thousand, then six thousand feet, and washed over us into the valley below. With powerful strokes, we swam upstream on the beams of that bright canary-cadmium cornlight. It swirled and surged and delivered bulging bundles of energy from out of the high Windex-blue sky.

That spectral, magical, religious light was pouring and powering on toward its own sea. That sea was fields, and crops, and the warming of the ground to change temperatures and climates and pressure zones and even the earth's gravity, wringing out the marine meadows' moisture all over the furrowed fields, on rice terraces, on both sides of the steep slopes, green vegetation all the way up from the wild rapids, giving way to willows and cypresses higher up, and then yielding to fragrant species of sumac, right where we were, and then, higher still, to towering piney pines straining to catch the solar wind in their needles and hold it, just the way the giant trees below did with the rains.

Up higher, the trees thinned out and gave way to shimmering green sheets and shiny shards of grass. This solar fluxing went on for hours. We kept remarking on the quality of the light, the magic of the day, the cloudless skies and the perfect weather, but in the end, these shared observations reflected only a tiny fraction of the rushing and streaming of our private thoughts. We were searching in vain for some worthy way to express our awe and astonishment at the ways in which this light show was working on us. It was reaching us here, in this long, long valley for this long, long time on this specific, specific day. It was fixing these golden images in a silver bath that was impossible to wash off. Those sharp shadows seemed never to move, and we seemed never to move. We swung around another curve and the road stretched far up ahead, cut into the side of a mountain.

The day began to be about never-ending, relentless climbing. It was all like a set of renormalization algorithms to corral and harness the infinite terms in quantum mechanics equations. We would

traverse a long passage and round another series of fractal curves, and then, it would start all over again. It was never the same, but for the longest time, it was also never different either. We searched subconsciously for tiny increments, for anything, for the littlest differences, for some kind of verifiable valid markings to prove to ourselves that we were making measurable progress up this valley. What was the name of this valley, this passage, this place? What difference did it make what its name was? Maybe it was too big or too remote for a name, maybe it had now or had had many names, maybe no one had ever bothered to give it a name.

What struck us over and over again was the realization that up here, how few people had passed this way in the whole history of humankind. Everywhere, there was remoteness, loneliness, danger, thinning air, dizzying heights.

Maybe that was it: maybe the ever-so-small evidences of *horizontal* passage were only able to register themselves deeply as subtle but lasting *vertical* changes in altitude. Even through our roadway rose and fell locally, on a larger scale, it began to dawn on us that the whole valley itself was rising imperceptibly, inexorably, carrying us up with it, up the steps like a child cradling firewood in its arms. The subtle signals and signs and metaphors were everywhere. The standing waves, and the foam, and the speed and roar of the river were talking about the effects of an early May snowmelt, but also about the nights and weeks and months of snow that had to have fallen high up on those steep slopes to put it there in the first place, and at the same time about the unceasing gravity wresting the water downhill as the carving riverbed itself kept dropping under and away from the river.

Maybe it was the images—a rock formation, four trees grouped together in shadow, patches and stripes of lime alternating with patches with stripes of kelly and seafoam and hunter. Maybe it was the hundreds of multithousand-foot vertiginous drops to the valley below. Maybe it was the way the half-built new bridges and the half-destroyed old bridges came and went. The mind attempted to choose from the images to select and store, and many of them just reappeared on their own, later that day, and then that night, just before sleep, when yet another new scene would swing into view around the bend.

It was like racing on a clipper ship, rounding Cape Horn to break the eighty-nine-day speed record from New York to San Francisco. No question about it, each of those days was the exact same; yet each of those days was somehow different. On that seagoing mountain going, you kept getting lulled into habituation, because you knew that the next turn would repaint your internal monitor with a startlingly fresh and continuous version just like the one before. We came back, again and again, virtually to the same spot. In front of us, we could watch the clock ticking and, in our minds, we could feel some sort of analog sweep of the second hand turning, but these geologic minutes never moved. The power and force and character and magnitude and uplifting flexing youth of these mountain walls were fixed and permanent and unchanging and they wanted to crush and rush in on you from every cliff and ledge. The sedimentary rocks, the porphyry basalt, the grey-specked granite, were sometimes naked and exposed, sometimes half buried under the road. The sluicing waterways cut across the enormous rockfaces again and again, carrying massive boulders and huge piles of jagged talus and scree. It was impossible to imagine how water this high up in the mountains could move that much weight over that great a distance, but it had, on some day or some night, or on many of them, maybe not even that long ago, with unwitnessed roaring force and power.

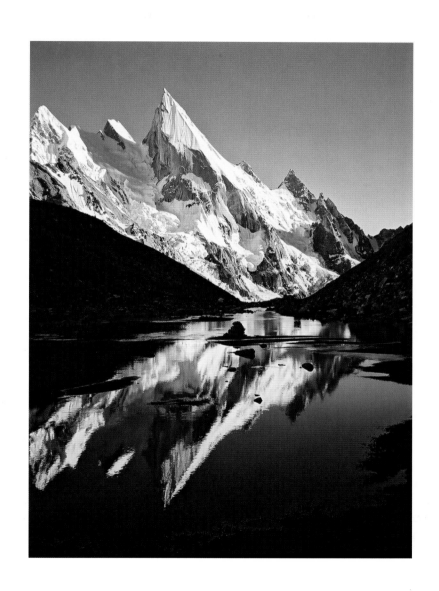

In tectonic time and in human counting, this frigid water was on its way to deliver life to humankind and cattle and crop, but every day, it also represented relentless ruthless eroding death to these lofty peaks, whose crowns and vertical sides were also racing away in the disturbed, turbid, turbulent currents below, now gray with silt, now flickering argent with sunlight, now nimbus with shadow. For over five millennia, people far away had measured and depended on the rise and fall of this river, but these powerful pursuing currents had been pulsing for much longer than that, ebbing and flowing through ten-thousand-year ice ages and subtropical thaws, through alkaline deserts and limestone lakebeds, nourishing immense thick Permian vegetation and flora that got baked over millions of years into huge domes of hydrocarbon.

We held our hands out the window to feel the water's cool spray, sometimes a rainbow at just the right forty-degree angle with the sun, sometimes a tantalizing respite from the heat and dust and gravel of the roadbed. It would have been a different valley on foot, on the back of a donkey, in a cart, or walking behind a herd of goats.

It would have been a different valley without the saxophone music of David Sanborn "Bums Cathedral" and the accordion music of Buckwheat Zydeco "Hard to Stop" and the percussive arrangements of the Miami Sound Machine "The Words Get in the Way" pouring notes out from our four speakers to soak the indelible landscape.

It would have been a different valley without us hanging out the sunroof on the slow-motion turns and in the racing straightaways. It was a different valley for each of us, just as your reading this is different from my writing this and remembering and naming how never-ending it all was, clearing away the big avalanches of rock with a Komatsu. It would have been a different valley with a different driver, one not as skilled, or devout, or safe, or swift, or steel-nerved, as when he came upon deep gullies out of nowhere at high speed, or when he encountered three cars and trucks squeezed abreast on a narrow twisting high road with nowhere to go but another inch or two between our tires and the edge. Time and again this happened, downshifting in a flashing motion from fourth to third to second while sweeping through yet another inner-core curve, sometimes crossing a little white metal-and-masonry bridge, sometimes braking hard to avoid a mogul and flashing through deep streams bisecting the highway.

Almost without noticing, we crossed a bridge to the other side and headed upward. We were well on the way now, counting down the kilometers, before it dawned on us that we were somehow looking down on the river from the opposite bank of the valley. Maybe our lapses had been caused by overattention to the bridges. Climbing at this stage, we never saw a single person or vehicle or animal or anything on any of the dozens of footbridges, or the wider bridges, or the big spans built to accommodate cars and trucks. Some were huge, built to hold tanks, heavy construction equipment, armored personnel carriers. All those bridges with no traffic were set down at points where the river narrowed, on granite piers just above the floodwater mark.

The passengerless bridges brought on this profound sense of yearning, of lingering promise, of the passing of days. When and why were these bridges built? Who used them, for what, and how often? Were they high enough off the water? What was carried across them? How much did they cost?

We didn't notice our first crossing. Our not noticing, and then realizing it later, made us hyperattentive to every crossing from then on, pointing them out, commenting on them. The upper part of

the valley was being suffused now with the flamingo and gulf shrimp light of a waning pellucid day. The river was flowing more smoothly and more gracefully now up in these reaches, tracing broad sweeping arcs and depositing the sand and silt and gravel into steeply banked turns. The air was taking on a noticeable chill, but to hold onto the day as long as possible, we hung out the roof into the blowing breeze. We were getting longer and longer straightaways, crossing rougher, browner terrain at altitudes totally devoid of plants except for some brave resin-scented shrubs, cropping up like puffy little clouds here and there along the highway. The evergreen fragrance hung in the air wherever the plants managed to survive.

We were trying hard not to take leave of that day on the road. There was a distinct feeling of having worked for and purchased something. There was this lingering wonder about what lay ahead, on the miles and miles of road to be traversed in coming days. There was anticipation and intense desire to arrive as we watched the numbers on the marker-stones slowly count backward. It was a recurring source of amazement and amusement that we often hadn't been able to make a significant dent in the distance, although our motor had been turning at very high rpms and we had been experiencing a distinct sense of velocity. It began to sink in that those fast engine revolutions had been in lower gears and our velocity had often been primarily angular rather than in a straight line. The temperature dropped sharply whenever we passed through a grove of trees flanking the road, places where hardy souls were somehow able to divert a high and reliable stream or tap into an underground aquifer.

It was cooler and cooler each time, the degrees were falling, the moisture was beginning to hang in the air. It felt as though we were walking in front of a big department store on a blistering summer day and had the air-conditioning blast over us whenever a shopper passed through the doors.

The shadows had been rising up the sides of the valley for three or four hours now, and there wasn't much light left. We strained to notice every detail. We watched every beige edge into dun, every sepia become brown, every brown morph into purple.

There was all this deepening, steepening, steeping, silent fastness that took on an air of palpable tension and hanging and repose, of marking the coming and going of one single day, of one single day that had earlier been so foreign and unimaginable and recountable, and that was now so close and vivid, this envelope of naming and recounting that was pushed outward by the unceasing geography, by our trying to describe what we saw along those pathways through the use of maculated lanes and cypress-lined allées that you yourself tread and recognize every day, serving up the faraway by melting down and recasting the familiar, as we in deep regret first switched on the lights and then later, clicked them to high beams, on final to Gilgit, meaning "mountainous place"

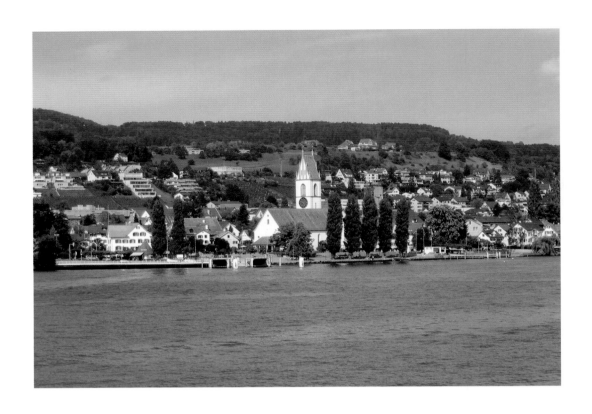

SINOPE

The things and thoughts that took shape and place and form in there, like a Dutch kiln in Delft, its systems and sounds spoke to you in so many tongues of momentary keeping, this place where the waters gathered to capture and release broad vistas, some kind of central railway station where all the lines and carriages and journeys hooked up and came together in fortuitous coincidences of magic and possibility, of nights and afternoons, journeying, judging, jumping from pageview to pageview while you waited and watched and listened for a clear message from them: from the colors and trains, from the friends, the temperature fluctuations and the objects and images and the soft caring comfort, the way you could step through the gate and emerge into a world of script and scriptures, fountains and fonts, beauty and beatification, this haven-heaven of trees and water and sky that libraried and shelved all the other places too, all the motion and noticing, streets and parks standing for something, highways and lands and landscapes so full of meaning that you waited patiently for them to speak of what they had encountered, of their own amassing of time and weather and how they kept coming back to that there that in fact was so wrapped up in here, blankets of snow, curtains of rain, pillowy clouds ready for giving forth, going forth without budging, the stillness and the specific imagery touching you and coating you like hoarfrost meticulously painting every twig and branch while you slept, waking to discover a bright new world capable of informing your dream while the second hand swept, touching and chasing the little hand and the big hand, the sky strewn simultaneously with moons in every phase, each where it should have been while you were turning in floral revolution, the hues and shades spreading mercy everywhere, the flux and flow able here for an instant to suspend their oar over the passing bowstream and see it become wake, proclaiming a whole imagery of narrowing, purification, illumination, discovery, reverential approaching, recognition

TRITON

So many nights, I laid my head on the pillow and processed the day's events, categorizing, saving, discerning, savoring and reverencing, sometimes barely even touching certain ones because of their power and flow, and in the midst of all this came again and again the ubiquity and role and centrality of water to them, the swollen rivers, the huge networks around their palaces and temples and cities, the sheer volume of rain that had to fall each year to bring all this on, the suspended moisture and humidity in the midday air, the reflecting pools and fountains, the lakes scattered all around and over and over again, that one gigantic lake, large enough to host sea battles lasting for months, even years, between enormous navies, the lake swelling and shrinking by 40 percent or more as it filled and emptied like emotions capturing and releasing the heart with each beat; maybe that explained their love for lakenite, for marble, for limestone, their need to rake the temple steps so sharply to ascend quickly and gain height, making a hill where there had been none, so they could be close to the gods and look down upon the treetops from above, trees and birds and animals, fish, soldiers, courtiers, royalty all bas-reliefed onto the walls, you could feel their urgency to have swordfights and follow royal processions with elephants and riders just fitting through the triumphal gates, dreaming the leaves, blossoms, vessels, fabrics, making them burst forth as quickly as possible from the stone to shout duration and persistence and then hear the echo of fragility and imperial impermanence and evanescence, the imposition of one person's will upon thousands of subjects to build something up, only to have it give way to inexorable vegetation and growth, roots, tree limbs, tendrils and vines everywhere, intermixing people and creatures, beliefs and alphabets, modes of dress and address, clouds of fertility, acceptance, calm, hunger, projection, nostalgia, embrace, celebration, ecstasy, intricacy, reprisal, satiation, saturation, engagement

Tarvos

The immense amount of projection, the huge quantities of scenarification
The relentless imagining awareness, the mind mindful of every gesture,
The waking and stretching, the Mercatoring of worlds all over the place,
The rewinding and pausing, the play button, the still life with fruit,
The questing questioning, westing, wresting, wrestling, trestling,
The flashcamera capturing that which is now sent as an attachment,
The wondering and pondering, the inhabitation of self by one's self,
The crossing, the encounters, the makings and reformulations,
The trying-on, the audition, the peerings and pairings incoupled,
The streaming hot tears and recurrent pain, safe passages to the other side,
The impossible inventiveness, the inner speaking and meaning, the intent,
The desires and repulsions of the bay, the time zones and hemispheres,
The recurring abundance of bud, the two and three seasons of growth,
The rails and tracks and ties and switches and semaphores,
The flowing currents of temperature and color and nutrients,
The combing, the mirror-scrutinizing, the looking and reflecting
The ether filled with waves and particles, matter and matter not,
The dialing and pitchfork tuning, the laws of large numbers, inflation,
The how can it be thus, over and under, the never giving it a second thought,
The congruencies aqueducting snow for leagues and leagues, evaporating,
The return on vestment, the talismans, the dressing area, talking to yourself,
The multiplications and raisings to the power of ten, extending from one end to the other,
The animation of fells and fen, the welkin breathing and comforting,
The copper and azure, the lambent crimson, and that sacred orange conifer,
The way the hoarfrost coating the branches seemed to be saying something,
The strenuous climbing, the contours, the tree markers, the highest point in the park,
The little book, the words, the writings in the margin, the tempestuous template,
The internalization and empathy and all the marching matching,
The patterns that drifted above the treetops, then above the timberline, then, the rockline,
The cold-fusion and superconductivity and scanning-tunneling,
The impossibility of description, the speed of arrival, the gating,
The smells of baking, the steady flames of the candles, the big duvet,
The score, the misting, the largest live crowd in history, the maize,
The incantatory magic, the coming up from beneath the surface of the ice to breathe,
The welling, the springing, the emptying, the recursivity, the introspection,
The way the light came spilling through the branches onto the wall and the leafstrewn rockbed

ALBIORIX

The way the streets and buildings and neighborhoods appeared,
The floors and flags and flagstones, watertowers and stoops and finials,
How they set off emotions here and now, and then there,
You chinked between the bricks and brownstone motion,
New and old, permeating permanence, skies and light-lights,
How so many of them trailed you, offered you, presented you, beggared you, clothed you,
A whole phone book of emotions and feelings that you could flip open and speed dial,
Those places addressed you in constancy, midblock,
The way the awnings flapped and the trees overarched,
And you owned the moment, forged the kettle of space,
Neighborhoods of shelves of Books of Kells, brightly
Picking, poking, blurting out their own names,
And everything that had happened in the spackling
Return, the eaves and panes and surprising columns,
Climbing upstairs out of the rain and snow to genuflect,
In contrition and sorrow seeking to face the whole
Circle of what had happened there, but those treads
And risers would not allow it, only coloring
Repair and riparian rights to those loud noises
Each week at the same time, so true that you
Waited for them, wanted them, strung them together
Like electroluminescent pearls swagging from
The bishop's crooks lampposts, ascended onto by
Ladders and chutes, all the drops coming down
Through the mists and glaze in slow motion so you
Could time it now, huddling under an umbrella
With the meal and the movie one more big move, one
Place that we could mark precisely with a finger
Inside on an impossibly precise plan which showed
The courtyards and practically even showed the furniture
By the fireplace that we coaxed into the warmth of mapping

PROMETHEUS

There was this perpetual morning, then perpetual nightfall, and those winds, the elemental, showy, visible forces everywhere you looked, this omnipresent sense of sacredness because you had been here and woke up early, filmed, snapped pictures, flowers and trees and beaches, those palms lifting up green shiny branches to display their undersides, the constant dramas that played out of who and when, by what means, and for how long, and then what must have been going through their own minds upon first arriving here, beginning to form spiritual thoughts and dream up images and connections, cause-and-effect relationships, making up words to apply to new fruits, and birds' sounds, flashes of plangent color washing up against the shore, and then to sense differences of season, of altitude, pronunciation, punctuation, weaving, we now know how it happened, it's obvious and tangible and explicit, the positioning, the placement, the shapes, the juxtapositions, clarity and joy in the flow—of waterfalls, lava, currents, clouds, streams, sap rising in the stalks and trunks and stems to make sugar, all this blending of waystationness and destiny-place, the temperature, the distances, the remoteness, your lanterns lighting the way, pitfalls and stamens and gorges, fumarole vents, size and scale and this ever-present three-dimensionality, the roads and paths to the top, every part of here became important, reinforcing, cumulative, aloha the same expression for salutation and valediction, holiness, purification, serenity, shapedness, sharpness, authenticity, raining down and ramifying off one branch, an eternity of motion, your eyes poring over the swaying grasses, the channels, the slopes, the shimmering, shimmying, soft indolent washing bathing light, trying to behold it, hold it, cup it, capture it, shape it, sound it and plumb its depths as it warmed the waters and the winds, the sky and stars guiding the outriggers so attuned to subtlety: avian flyways, nocturnal constellations, temperature differences, moisture, fragrances carried a thousand miles, anything, everything, connecting us to each other and to them, to our wandering closeness fitting, fuming, tightening through time to inexorable congruency, then the island clusters rejoining, fusing together to rise again for one single day to make legend truth

UMBRIEL

Tell me how you would describe it to someone else, that anticipation, the waiting, all the wandering, wondering exploration and capturing of those landscapes and skies out there, and processing them, storifying them and birthing Gemini siblings in twos and threes onto the hard drive, and from there, to the flat panel display in the mind, in the mine, how all these places you explored and put into your basket and so gingerly brought back to be braided with your skillful fingers and six senses into highways of surprise and revelation, your vast vistas expanding ultimately to embrace and peer out the window and show all breathing and forging in that element-making crucible, every minute of experience rehappening and bursting forth to perfume the balmy spring air with orange and jasmine, lavender and rosemary like olfactory lanterns lighting our steps and showing where the sylvan paths would merge and lead, to the dock, through the stream, and across, on the other side, along the bank to the waterfall where we bathed and drank and swam, laying out a picnic of cheese and bread, then eggplant; the water winelike in its power to intoxicate, soaked and mantled in the golden light, plums and letters, drawing and shaping, global positioning into whole new neighborhoods, tree branches making our own arboreal nave out of the streets, how we ran down the hill to fetch a pail of water, day and night, dawn and dusk making noon into twilight and midnight, the larks' first singing, this agriculture and raising, the way it was so quiet, opening the door and admiring the mangrove trees, never failing to give thanks in prayerful homage for the benediction and beatification and beauteous bountiful blessing of first greeting, how it never stopped playing and unfolding and returning to that place, is by this medium possibly one of the ways you might describe it to someone else

LEDA

Tell me about it, race to gather up all these overflowing emotions and blazing images swirling together, sit on the floor and sort them into piles, then into files, the Herculean challenge not being to remember and recollect but to try to keep them all channeled and guided and rivered within the banks and shores and daynights of feeling and experiencing, lying on a raft under the stars with just your toes dangling over the edge in that coolflowing broad meandering current, how that and this could swell the streets and parks and benches and buildings full to bursting, how certain themes just wouldn't let go of you and began to pavilion you even as they simultaneously aquifered you straight down the middle of the country, maps elevatoring up and down in the heat bound together with glue to make arching canopies of projection the way just one word—begonia, or boxwood, or tasting two kinds of ginger ale—could put you at the center, in the center, centering you and refusing to loosen that grasping grip, the tributaries reintersecting, ticking minutes on watchdials recalibrated to gardens and light furrows that we danced gaily down as far as the eye could see, corn and cornflowers and sunflowers arranging themselves and growing as we inched forward in gravity-thrall, the snowy flakes spicing our cheeks in hobbyhorse meadow on the edge of hobbyhorse forest constantly flipping back to hobbyhorse square, hobbyhorse terrace, scooping the sunsummer and stepping back in awe to witness that photonic flash flood finally line up just right and flood float floodfill floodflourish whole lives of living on the lintels and sills, draped over the fences and stoops and the straining hibiscus, mallows in the marsh telling us over and over with pink and lavender and white signifiers, us straining to process and interpret those messages of fruition, arrival, meetness, justification, the right orthogonality of it going critical and saying this has never happened like this before, and never will it again be this way, this branching and stemming and grasping in just this fashion all this specialness and preferencing volume after volume of leatherbound books on the shelf waiting for us to turn their pages, the morning crosstown streets brimming with promise and premise as we canoed and rowed and kayaked in the knowledge that it would recur and again dazzle and flash in all its bountiful benediction, only not quite like this, the exact way the sun came and went, golden arrows in spate, how do you perfectly align a person through some impressionistic imprecision, a gold coin with rigid edges as shiny as the day it was minted Aegean ages ago? It had this inexorable tendency of going somewhere, of that lining-up and being on the verge of fusing, perhaps one of its chief marvels a sense of arrival and departure, of almostness, of straining to make sense out of it like a vivid just-dreamt dream, all quantum-mechanics state superpositions and knitting up scarves and hems of logic, tapping and hammering and mortising the trusses until they were plausible and read right in the mind's read-write, what was in fact unfolding and unwrapping and undressing and uncovering was the way that solar tide rolled in just on schedule, in perfect alignment, and then the beam massing them into superhighways and rotating them ninety degrees to parallel the brimming, swelling water

IAPETUS

Because of your love and care and concern for water, what some may have described as a bit of a fixation, there was no way I could prevent mixing thoughts of that river with thoughts of you, you bathing or drinking or wading in the pools and shallows, you taking pictures of it, you writing about it or sketching it in those freehand drafts that you'd leave on the floor after a long night's limning, the way you constantly extend that life-affirming drive to so many growing things, animate beings and then you pull them all under your blanket up close to you, under your chin to embrace and engage and encircle and encompass water too, the immense significance of the water to the people along its banks, their culture and commerce and cultivation, they would beg for it, store it, steal for it, hide it, purify it and worship it in shrines far upstream where it would pour off the eaves and fill the cisterns and then be made holy upon being collected in their chalices, granite and teak, rushing through the core of the bamboo, the people sometimes went to war over it since they saw it for what it was, a highway of food and soil and oxygen, a conveyor belt of cleanliness and climate—no wonder they esteemed and revered it the way the Maya and the Egyptians and the Incas prostrated themselves and built up whole religions around the sun; certain renowned hydrologists calculated that this river's hydro energy potential exceeded the BTU output of all the neighboring nations, needing to be considered in light of the fish that thrive here and nowhere else, not to mention the impossible-to-imagine freshwater dolphins cavorting in the boat's wake the way you were so apt to breast the surface of consciousness and splash down again, launching a swift and graceful dive, and far downstream, there was a whole different way of life, the irrigation and the flooding influencing the vocabulary, the dialect, how they dressed and entertained guests and even how they counted, their number system based on alluvial rhythms; once you'd been on it and in it and swam from bank to bank and made tea from it, you found it never left you, like you never leave me, the urging, urgent downstream release of the waters hundreds of feet up the sides of the mountains and then thousands of tortuous, twisting, winding, sinuous, undulating, curvaceous miles on its march to the sea, merging with other tributaries until it ran straight, broadening and widening and flattening and fanning out to braid and rebraid itself to spill out over the marshes with their herons and the swaying grasses, knowing that this had been going on day and night for centuries before we imagined it and then we began not so faintly to appreciate how you, too, would not ever cease

ANAKE

Maybe because of some kind of deep visceral connection with you and your work, it had a tendency to come back with some degree of frequency, when I was journeying to the other side of the world, or equally, when we were sitting face to face, sipping tea, never far away like that cat appearing through the doorway or somebody's dog that somehow attached itself to us for a few blocks on a bright afternoon, eternally conscious of its position on the planet, near its neighbors, in the ocean, the globe, the colors, the vivid shining fresh greens, and the mango yellows and papaya pinks, they all sparkled in the light, they glistened and beckoned and revealed all the patterns and sewing that stitched up to make them shimmer and wake you now to everything, to the elevation changes, their deities and forms and places of worship, trying to make sense of the magic, the animals and spirits and sharp sudden realizations of affinity, and fitting the extraordinary into daily living, making something as close as water take on shape and animation, the rain, the river, the pool, the sea all in a cup, all in that boat that brought them here for fortuitous naming and discovery, the making of buildings and fortresses and temples and palaces, streets and roads and bridges, always returning to you, the races and peoples and customs and devotions flashing at each crossroads, understanding that the randomness was not random, it had a pattern and a purpose and a mission to it, wanting to sit down and eat it, consume it, combine it with every part of me, how just this one little tile could from now on affect the whole mosaic, like recurring musical themes, a painting, a café, the sound that indicates the subway doors are about to close, they were all here amidst the birds and the swaying, fanning, branching leaves that give shade and succor at midday, it so one of a kind and simultaneously containing and contained in every one of its cousins, what you found yourself thinking about when waiting for the program to boot up, or between floors in an elevator, or after shutting your eyes and rolling into a comfortable position, and listening to the grapes ripen and the newly filled foam settle, drops alternating with flakes against the pane, the wilderness and solitude, the purity and purifying closeness of it melding and melting and merging with you, and then you with me and there, mountains and valleys

JANUS

The whole point is to race down a quarter-mile track as fast as humanly and mechanically possible; it's the reason for the uniforms, the helmets, the decals, the bright colors, the sponsors, the nicknames, the deafening, throbbing, exploding noise that you can still hear ringing in your ears hours later, the tension, the coiled anticipation, the compression and relentless release of three full years into a day, the oil slicks, the blown engines, the funny cars weirdly mimicking standard street models (doorslammers), muscle cars, nostalgia vehicles, the rail jobs, and everywhere the engaged crowds amidst the tow trailers, the timing lights, the nitrous purges, their dress, their behavior, their music, the posture; what you're explicitly testing are things like acceleration, and rpms, and top speeds; because of the closeness of many of the races, times are measured to an accuracy of a thousandth of a second, this interval sometimes the margin of victory as judged by the electric beams at each end, and then it starts all over again, you have to test yourself, prove yourself in this automotive jousting by winning one-on-one until there's no one left; it's ultimately about fearlessness, nerve, physical strength, accuracy, consistency, intuition, zenlike driver concentration, zonedness, engine tuning, tachometer reading, gear shifting, throttle modulation, acuity, chamber capacity, double overhead camshafts, intake valves, piston rods, the right kind of lubrication, metal casting, metal strength, sensing when metal fatigue may be presaging metal failure, the number and configuration of cylinders, frame type, suspension modification, vehicle construction materials, the wheelbase, horsepower-to-weight ratios, and importantly, whether the engine is normally aspirated or masted with souped-up rigging; with air-adding devices such as turbochargers, superchargers, or injection, they grab air, grasp air, gasp air, suck air, force feed it, cram it, ram it, jam it, compress it, saturate it with vaporized fuel and then detonate it, thousands of exploding bombs, thousands of degrees, millions of particles, trying to flee somewhere, anywhere, torquing nowhere else but through the drive train to the road surface; a top-fuel dragster powered by a 500-cubic-inch V8 hemihead engine running a mix of 85 percent nitromethane and 15 percent methanol can generate over 6500 horsepower, propelling the car to speeds of 330 miles per hour in 4.45 seconds; when they can bring this off, they are for that time period the fastest-accelerating vehicle on earth, swifter than a steam-catapulted jet fighter slung off the deck of an aircraft carrier, faster even than the space shuttle's launch package; they can ramp up speed so quickly that a competitor simultaneously crossing the starting line at 200 miles per hour and holding that speed for the full quarter-mile will be beaten to the finish line by the top fuel drags starting from a dead stop at the same moment; the race is about elapsed time, and elapsed time is about the burnout rituals, in which the wide, no-tread soft rubber compound rear tires are spun at incredibly high revolutions with the brakes on, heating the tires up to their optimum working temperature while also laying down a sticky coat of rubber for maximum tightness of grip at the precise moment of firing; at the bottom of the Chrondek timing lights Christmas tree, you want the car to already be vaulting forward during the split-second interval between when the last yellow light goes out and the green light goes on, giving you a holeshot on the other driver, at the same time taking extreme care not to redlight and disqualify yourself by crossing the beam a millisecond too early; in the blink of an eye, the race is run, the multiple braking parachutes deploy, and the intense deceleration produces 5 Gs of force, enough to detach the retinas of unprepared drivers

EPIMETHEUS

This feeling of incredible wonder and awe at the specialness, the rarity, the total otherworldliness of the streets' names, the trolley tracks, the palms, the arching trees over the avenues and boulevards and alleys, there was this indescribable recognition that the street life here is not like that in Paris or Rio, but there was also this constant comparing with those and other cities, Berlin, Milan, Zurich, New York, Buenos Aires, San Francisco, here more cleanliness, freshness, neatness, the washed sparkling light telling you unnoticed things about climate and air quality; you found yourself breaking into spontaneous episodes of gratefulness at the way people moved, how they stood in relation to one another, their faces, their pace, their body language, you kept pondering how many things were the same, and how also so many were utterly different, their almost palpable connection to and awareness of the past, the monuments and plaques and signs, the fonts and nomenclature, the flapping flags, the seals on some people's stationery, the statues seeking to be old in the newness of settling the place just two hundred years ago on top of such real oldness, settlements perhaps forty thousand years earlier, producing wave upon wave of one-second nostalgia, this melancholy, then happiness, then gaiety and determination and yearning to have lived here in the old days, these repeated projections and the daily carrying of the past in a backpack facing your chest like a small child, the water, the rivers, the bridges, the scullers rain or shine, the bay, the sailboats, the wind, the sky, those clouds, always drawing that place nearer, through television, the Internet, cellphones, wide-bodied jets on longer and longer nonstop flights, how fast fashions and the movies and music seemed to spread, but just not quite, because of the remoteness, the reversedness, the veneration of spatial and temporal and oceanic and seasonal distance, of differences fine and grand; if you could manage to insert ten or twenty years into your own life without knowing it and live somewhere for that time, it would be here, the coffee, going to work, the glistening sandwiches in the display case, the sporting events, the dramas and festivals, people from here living overseas, many thousands of miles away passing a building with this place's name on it, local art schools, a form of your found land, all this you wanting to be here for a while, feeling the people here wanting to have been here a hundred years ago, this ever-present reenactment of its population and discovery, the wanting so desperately to have been there, to hold onto something and have it be exactly the same, even if just for a little while

Dysnomia

There is no other way to wake up in a new city than to leave the late-night curtains parted wide and to come face-front up against the picture window of the next day like a Super Bowl High Definition television screen. In Miami at 05:17 on 5/17, the sky was all subtlety, all pastel, all dreamchalk, all indirectness and feline softness spread all over sheets of translucent rice paper.

The light was soft coming from nowhere and soft coming from everywhere. It was indistinct on its way to distinct. It was non-speaking infant on its way to seasoned spring. It was watercolors of water colors.

From such a height and in such light, the placid seas were also heavens and you were circumnavigating in an argosy, running before the solar wind upside down with the shuttle's bay doors totally exposed to the universe. It began to dawn on you that there were no shadows but very soon there would be. That led to speculation and wonder about just how bright and brilliant it would ultimately get, just how shiny and reflective and glimmering it was going to become. The incandescent light was giving birth to fluorescent colors. All day long, the eerie brightness of that light gave every indication of getting ready to shudder and break and explode. You knew you would end up in a parting race with yourself as that day wore on, to try to depict, describe, and reveal openly all the layers of that chambered shell.

After a time, the laced veil was gone and that breathtaking blue-green clarity had arrived. Dew was turning into sweat and tension and displacement. All the lapping shoals and tides, aqua shades and tinted glass, were mixing in the mind with the projecting balconies. Those elusive paths and sights were suddenly coming to a verge.

They were jutting into the jetties of noon, amid an overwhelming sense of water, water that flourished, flooding filling water, water that was braiding and mixing and overspilling into rivers of light. That light was inlet water. That light was intracoastal water. That light was land-hugging water in canals and bays. That light was water wrapping islands in fuchsia. That light was reverse water spanning bridges and projecting into peninsulas.

The images burned themselves into the mind's cartography in a thousand shades of cyan, magenta, and blue.

You felt as if you were allowed to touch anything. You followed that boat and its speedy wake around the cape and into the channel. Finally it was here and you were on it.

You recognized its inevitability but you too were astounded when it came to pass, the long-awaited and long-sought clouds of afternoon rain. It was raining sun on the sea. The rain fed the blazing bougainvillea and superheated the hibiscus to a trumpet voluntary of bursting. In the shade and in the sun, you and the world began to close on closeness, to fill and get stretched to limits. There was candid blanching, white structures, white breezing, white sand, white wind, white rippling, white etching, white edging all around the buoyant ships, bathed in white skin and blinding white lights at night

NIX

They kept coming back, those views of Tahoe from the high peaks, from aloft in the speeding chairs, from around the turns into full panoramas, straight-on, and all the shapes they assumed—of fertile deltas, of bulging crescent-rounded triangles, of half-glimpsed stealth wings flying through airy glades.

With the delivering full moon marching across its waters, it was its own sea, it was nearly one of the five Great Lakes, it was virtually a boreal ocean. It had its shores and sounds and bights and coves and peninsular microclimates. It was so clear, so translucent, so blue, so cold, so high, so brimming. It was one big rounded waiting calyx, a chalice of elation and happiness.

In the end, what you were left with was the feeling of being ever more deeply in love with that vivid, sharp, glancing, inevitable light, all that merry, shiny, reflecting chromium western light of day, that glistening cherry candyflake metallic light, that snowpack light, that rockface light, that blessed blue-white umbral light under the high cliffs and ponderosas, that eternal lipgloss light bright enough to keep the huge lake from ever freezing—in that light, everything melted and flowed, it was intolerably sweet, it rafted and ran in all its feeling and loosening and weeping.

On the night of the vernal equinox, that light vibrated inside you like a bell. It dripped like upstate sap, its dunning tan trickled and saturated and ran like liquid gold lacquered all over your face and neck and hands and fingers, that light followed you everywhere, it filled and ripened you, it made everything suddenly so dear and transparent, it opened widths, it wanted to drench you, that light was full, ready to rush thousands of straight-shot, then curving, then meandering, then intertwining miles down brimming valleys and gorges and plains, to the mouths of puissant rivers emptying into one another and ultimately, into the Pacific

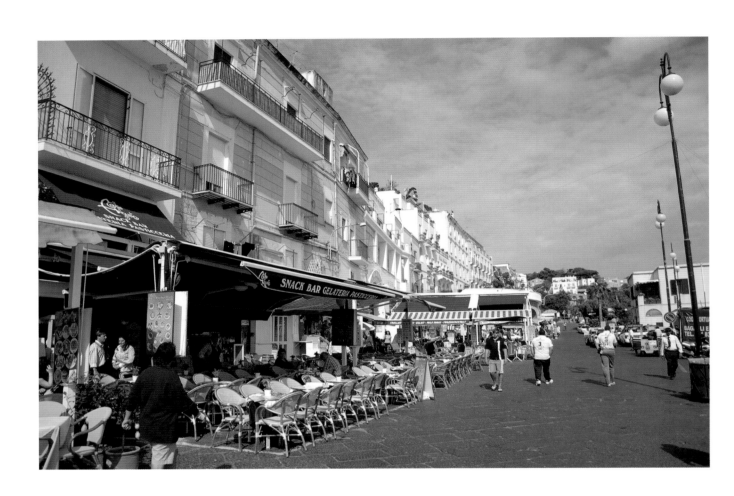

CALLISTO

You will end up making a positive and powerful film about your visit to Capri, what it does and what it means, building on the cinematic history and role and position of Capri: Capri in the mind and thought and rapture of Italy and the whole moviegoing world.

In the movie, one thing that will dawn on you will be a bittersweetness and fragrant sorrow at the fact that your stay in Capri is so short, maybe as short as one day. It will say that every stay in Capri is too short, no matter how long—a week, a summer, a year, your whole life.

One of the deep attractions of Capri, one of the reasons it is so loved, is the breathtaking beauty everywhere one turns on Capri. There, it is beauty that stays and evolves and shapes and dwells. We bear witness to feminine beauty, masculine beauty, geographic beauty, mathematical beauty, and we are taught to feel that some meaningful part of the attraction comes from the evanescence of the beauty, from its flickering dazzle. The same incredible sunset every day would get old quickly and begin to cloy. Usually, the observer is the one who is fixed and the beauty is fleeting. What ultimately reaches you about Capri is how it is the other way round, it is you who are fleeting in the face of this timeless beauty, revealing and reminding itself to you every day in so many ways.

In one of the restaurants, up on a hill, you can eat alfresco under a superabundance of lemons hanging down from the trees and the trellises. You smell the lemony, citrusy scent. The lemons are there. They are about Capri and the climate and the weather and the know-how that has raised and tended and coaxed them into that sweet, intense, bottle-glass-colored liqueur of theirs. When they drink it, they're loving their own island, they're giving joy to the land and sun and leaves and branches that so biblically have brought forth the yellow fruit to give them joy. You bask in the sunny lemon imagery of Capri—the ways they have localized and claimed it for their own, the way they are so proud of their healthy lemon groves, lemons everywhere, lemons hanging in the air and floating in water the way the whole island floats in the sea.

Maybe the lemons somehow serve as a metaphor for the other fruits of Capri: strawberries, oranges, grapes, limes, melons, blackberries, raspberries, and especially, the figs. There, the figs are full to the breaking point with summer. Their bellies grow, their goblets are poured to the brim with ripeness and sweetness and taste. They are like the whole Mediterranean before Odysseus set sail home. The figs repeatedly shock you, because each time you bite into one, you immediately jump back through all the hopscotching squares of fig-scents you have swum in all through the Capri day, pools of scent, hedgebushes of scent, waving grasses of scent whenever you pass under one of those ancient trees.

In a way, passing in and out of the figshades also prefigures the experience of entering that special blue Capri grotto. Late in the day, after everyone has gone home, the wind and waves pick up, making the approach a bit chancy on the surface, with the water crashing against the mouth of the opening. By swimming a meter or two below the surface, it is much calmer, and you can enter. You open your eyes while still underwater, coming through brightening shades of being, all the way up, up into the cerulean temple, that marine atrium, and you are able to swim in and drink and connect with that light, that water-life. Inside the grotto, all alone now with the fading light and the crashing seas outside, you feel as if you have been allowed to penetrate into one of the mysteries of Capri, one of Capris of Capri, slice after slice of Capri arranged neatly on a plate of Caprese-Capri.

You feel bonded to Capri, you feel as if you and she share space and intimacy. She shows you proudly all her naked self draped in those shades of blue, shades that penetrate and illuminate you by swimming alongside you in the water. In the light, your eyes begin to adjust. On a summer's night, your eyes become seventy-five times more sensitive to light after being in darkness for a quarter of an hour. The blue gets brighter. The blue-red shifts years in time and space, the blue paints the ceiling and walls of the grotto, the blue sets off all kinds of transformations. In the grotto, because of the light, the land becomes sea and the sea is changed into land: in there, the light of the sky comes from below, while the light and look of the land are above you, on the roof of the vault.

It thus becomes setting and theater for role reversals, of mutual transference, of railcar switching, all driven by that Windex light coming in from below. After a time, you appreciate its maritime wonder. You begin, by swimming in the light and the water, to see how it all works, where the color comes from, how the light from the sea illuminates the grotto from a huge undersea opening in the side of the cavern.

You feel like you're swimming in the sky. You're treading water in the air, you're a bird, and a fish, and a mammal all combined, with breasts and fins and wings. You love the water, you find yourself crazed and excited to have returned to your watery homefluid after all those years, eons, of being on land. You find yourself drinking and swallowing the color, bathing in the color, at times, like blue milk, at others, like blue bluing, at others, so Italian blu, that you want to reach for the Derwent colored pencils and apply it to paper, blue, blu, blue, blau, blue, bleu, blue, azzuro, On Being Blue, on being in this island of space on the island, and then that whole process turns around and enters the grotto of your brain, now painting it with pastel and deepness, with lightness and boldness, with treble blue and bass blue, with all the riverine, watery, mystical, magical, mysterious blues of the musical blues scale. You don't want to leave, with the water holding you and embracing you and buoying you up and cradling you in all its five senses.

By keeping your eyes open under the water, you can see that the opening you swam through into the grotto at the surface is copied and repeated below. There is another submarine opening. You want to stay, you feel the tidal tugging of the Sirens, the mermaids, history and epic narrative. There is a hold on you, something is embracing you, someone is beckoning you to stay, Capri is telling you to send a message back home that this is where you can be found, this is where you and nature will interchange selves with all the happiness of playing porpoises, this is where you will stand astride two dolphins and ventrally race-row-run-ride through the water, this is where you will be in vigorous motion and rest. This is where your hair will be tugged and stroked, this is where you will be conceived, key-stroking through all the power functions and then being born, this is light, smelling the sea and salt, tasting your partner's flowing tears and sweat as you also watch your own partner, your little self, your arms and eyes, following that primary of primary colors—blue—on this island, this isola, this blue self floating on the surface and plunging into its depths, drawing the island and your partner to you in a soft evening embrace lit by flashing comets of blue.

In the movie, it will surely be difficult, but it can be done, to capture the scents, and especially the softness of the air, showing close-ups of leaves and flowers blowing gently, faintly, in the breeze, the light uplifting of a printed scarf, or a page being turned in a book left open on the table. Someone will place a hand to touch hair, and then that hand will pause, and the breeze will lightly, imperceptibly, move the fine nape hair on the back of the hand.

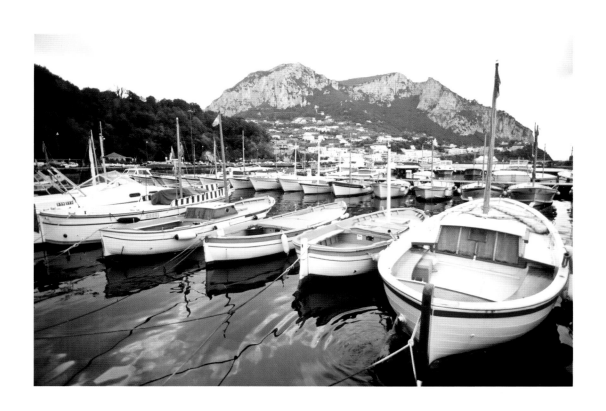

Juxtaposed against all the softness and delicacy and ineffability of Capri, is the sheer power and ruggedness, and the size of its limestone cliffs, its soaring frescoed and watercolored vertical spaces. Those huge, open soaring sheets of rock act as a big drive-in theater for projecting films and thoughts. That rock is stable, permanent, fixed, and immutable, but it is also in constant transit and transformation. The rock is patient and incessant. It is director and actor. It defeats wind and waves and sun and earth, but it is also being transformed in a forever makeover of storm and temperature and tectonic griddle.

Capri is framing and revelation and epiphany. The light is saying slow down. It is asking you to consider and reflect. The light says notice the tesserae in the mosaic pattern in the floor of Tiberius's palace; notice the shard-shattering side of the emperor's cliff; notice the houses marching down the side of the hill; notice the pace of the people and your own pace; notice the synchronizing of the catchments here with the fountains of weather, the sailing of stars and moon, the lazy, hazy opening of blossom.

The visual details are always feeding back and making you taste: sun-dried tomatoes, and melanzane and basil, in fine gradations against the back of the teeth, the wine in its own grotto, the roof of your mouth.

This heightened awareness flows from the hundreds of shots snapped by your mind throughout the day, as you ride the funicular, the port falling away from you as you ascend, rising to meet you on the way down. All the subtle fragrances which you put on the neck and behind the ears, in the wrists and elbows and behind the knees, the scents of rosemary, and garlic, and the sea, and grilling peppers, and baking bread, all like a little fragrance bag placed by your bed for months to help in sleeping, then given to a friend to hold and keep and remember you by while you sleep.

The light brings close things close and makes distant things close, like the white scarfwake of a boat moving in the sea and the sun. The light ends up exalting and showcasing nature, mixing sea, land, and sky like the buttery leaves of a croissant. The light purifies the water and makes you want to float, and cast off, and drift, and swim and dip your head below the surface to see the flashing aluminum foil underbodies of the schools of shiny fish. Swimming in the Capri light makes you yearn to spend lots of time in the sea.

The Capri light listens to you while you are crocheting all those breaktaking crossvalley Anacapri-Capri vistas.

All this, and yet Capri within bounds and limits. Capri not the Uffizi. Capri not Siena's Palio. Capri not Boromini's nor Bramante's nor Palladian tracings.

Capri-Sorrento, Capri-Naples, Capri-Ravello, Capri-Amalfi, each a stunning revelation alone just out of the shower. Capri as departure and destination, Capri as home, Capri as inspiration and generator, Capri as mother and father, Capri as same-sex and not-same sibling, Capri as and in you, Capri as adventurecoming, Capri as fate, Capri as source and font and power and energy, Capri there right now, melting in the sun, Capri still warm on the stove in October, Capri kissing and lapping back at the waters, Capri as turning point, Capri the framed map just inside your door, Capri highway, river Capri, Capri your bed and softpaste ceramic, Capri leaving Capri, wound up Capri setting you off to think up and carry out plans, Capri as slicer of the Gordian knot, Capri heat through lace fusing celestial bodies, Capri's credits finally rolling as Capri the Great Attractor

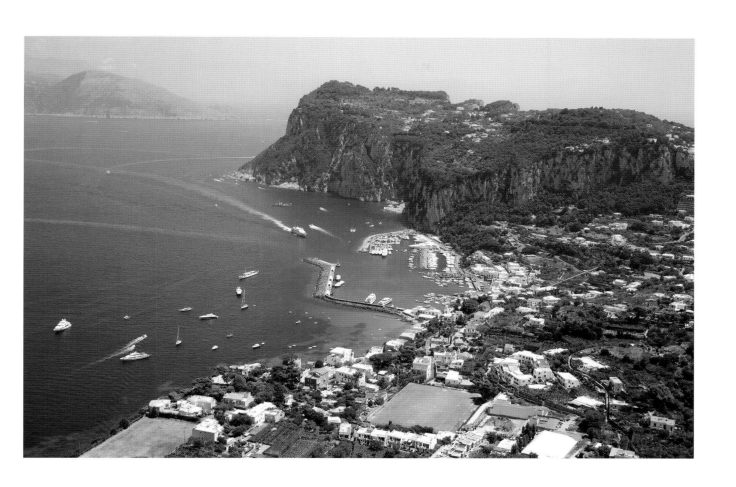

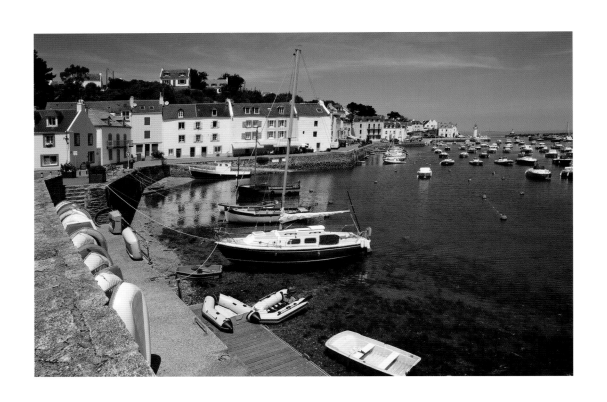

Europa

How long did it take for your bed to get warm and cozy under the piled up-tapestries in the un-heated long house in that raging all-night storm in Brittany? Did you too start awake and cringe over and over at just missing that pedestrian who appeared ghostly in the headlights out of nowhere, weaving across the road drunk on the fiery Breton Chouchen apple spirits? Arriving there so late, having seen none of it except in photographs that had not yet fixed—the shapes of the houses and their stone roofpitches, the windmills and watermills, the resemblances more to Wales and Cornwall than to Tours and Ile-de-France, the thickness of the granite walls—then eating the thick vegetable potage puckering on the stove, and taking to bed all the legends, the religion, the mystery and history, meant that when we woke up, we felt as if we were somehow already part of it, we had stewed and simmered and steeped in it enough to end up owning it.

That sea air at that *manoir*—its saltiness, its softness, its closeness—it had to be touching you as it was touching me. I stayed up well after everyone else every night, waiting for your call, but the bell never rang. Sure, you didn't have the number, and neither did I, but in this land of magic, maybe it would have worked, an electromagnetic spark arcing and arching through the ether after midnight.

Do you know that *Le Grand Meaulnes* was one of the reasons Gäel brought you? Marc and I thought you and he were a couple. What did it matter? What moved us, what made a big and lasting impression? What did we learn? What small details did we notice? What were some of the last things we thought about just before drifting off for good? What key things did we miss? How did we see the world differently as a result of being there? Will you ever have the chance to be alone with three people like that again?

The hours filled with tremendous imbalances of feeling. I knew it was going to kill me as I had never perished before, when you said farewell. I never moved because I knew I would never know you, you were always holding back, you were never going to tell me, to reveal enough significant digits of pi to circumference us.

Much later, it suddenly dawned on me that that *pigeonnière* had been sitting there in our midst, all the time in the night, in the round, with its low, low doorway and those slices of stone piled one upon another sloping in toward the permanent oculus in the top, with mailbox-like openings all around the inside to house the birds. We were able to find shelter in there, the four of us, looking up at the light. It was our birdhouse, it housed us, it held us close to one another, so that we could have meat during the winter months.

And still there were no messages from you, no signs from you, nothing at all from you. For weeks, every telephone call (I disabled the caller ID so as to enclose each incoming message in wrapping paper and not to know) might have been from you, the postcards, the unidentifiable envelopes I opened fast, but no, nothing whatsoever—how could it have been possible that you were not thinking of me? On some obscure cable channel, you had to have somehow watched me dash into the room and snatch up a message straining to count the signs until a decision could be made as to true origins.

Brittany in October's wake featured quais and bridges, outlines and indistinctness suddenly shattering into shafting light revealing last and next May, vehicles for road and for water, the slow movement of people and day. How could they cut and lift these stones? Who lit the roaring fireplace? Who painted the grandmother's picture and so accurately photographed the beauty of Gäel's sister Marie-Alix (who was married to Didier, who had three sisters, among whom was Laure), herself a virtual Gemini of Laure?

You had never before encountered combinations of these letters, like seeing Finnish, or Turkish, or Thai, bright Celtic rubrics splashed on golden foolscap. You said them and figured out ways to get others to say them; you flipped them, spilled them, spell-checked them over and over to yourself, with the images blazing and mixing, of the manor at Kerprigent, the flat, wide beach at Louannec, the butter-drizzled créperie and the sugar-sprinkled cathedral at Tregier, the polychrome-wood chapel dedicated to Saint-Gonéry at Plougrescant, the castle, the moat-boat, the pond surmounted with flirting geese at Keralio, the solitary house at Keriec/Treste, and the unceasingly winding roads through Penvénan, Port-Blanc, then Perroz-Guirec and along the Corniche by Trégastel, all spilling shellfish out over the table onto the floor at Locquémeau.

All those special Breton words were special parts of her, the unknown: the mor, meaning "sea," the goat, meaning "forest," the ni ho kar a greiz kalon, meaning "we love you with all our heart." There were words for your eyelashes, your skin, your fingernails, your breath. In the cloister with the shining courtyard grass, walking close to speak low. At times, our hands brushed against one another. The outside of my right hand once fit exactly into the inside of your left hand and stayed there, in front of their revered statue of St. Yvo, in the light reflecting off the stained-glass. Neither Adam nor Eve had a stitch of clothing on, so they were holding their hands in front. Near the baptismal font, there was a skull stuck on a pole with a crown above it, which the parishioners walked under during the ceremony called a *pardon*.

She was becoming you, or maybe you were morphing into everything hers: your middle name, your passwords, your nine-digit postal code. Things became defined by what they were not. You were constantly mixing the solution, pouring it back and forth between one who you knew loved you and you didn't and one whom you loved so and could care less, hitting the brakes and then the accelerator, trying not to let on, to let anyone know, trying to speak while keeping silent, trying to send more information than had ever been sent before in a single signal, trying to let words and tones speak for you only to those who were listening.

Her presence in our presence set off all sorts of combinations and permutations. When we walked, it was sometimes one group of four of us all together, and then, six versions of us broken into two pairs, and then, three versions of the three together plus one off to the side, and then, each separate from the others, four selves, lost in the wind and the mind and thoughts all along, all alone. Her scent a hyperawareness of scents. Her language, her word choice, the timbre of her voice elevating conversation, removing coarseness. Her posture affected our posture, her manners, our manners. Her breath in the darkness, in the car. Because of her, whole kingdoms and classes of things were identified. Always, an awareness of where you looked and stood, of where she looked and stood.

And still, while I was furiously trying to vent you from my mind, she was simultaneously zooming in from every corner of the universe, vacuum trying to jam all of deep space through the airlock. Months in orbit, new records for longevity, immense pressure, war raging on the margin.

That Laure, that Brittany, that time, we loved her because she was so. She divorced, the dyad died or maybe we were dyed and died, we did, time ran out, the option expired. We went there to flee. She wanted to come and she didn't, she was there and not there, an electron-fog of superpositions and grace-states.

They watched the careful drawing of the house, wedged precisely between the two enormous pink granite boulders facing the sea. Words for foam and spray and mist: *l'écume, la mousse, la brume.* Marc and Gäel moaned about how much time it took for her to get ready in the bathroom each morning, but what delight they took throughout the rest of the day under the ceiling of her Sistine Chapel! Inside, she posed for the camera, angelic in beige cashmere and suede against the freshly painted stock still along Proust's *Circuit de la Côte des Ajoncs* ("gorse"). With the hanging blackberries and hydrangeas, and boats aground and atilt at low tide, all the windswept, careful, repeated placing of statice and heather in her sunsetting sunhair.

In that soft yellow light, the beach was an open watercolor kit, tiny shiny pools of water standing in each little tray: red iodine, green chlorophyll, periwinkle boulder, the raucous gulls wheeling against glaucous clouds. Taking note of this, taking it all in, one of your amaranthine thoughts, there from the top of the rocks: the moving clouds, the shifting light, the shapes of the stacs, the wind, the height, the 360-degree perspective, the depth of the sea, the sound of water, the reaching tide, the moss, the vegetation, sharp lines incised into stone, the needles, the islands and peninsulas hinging together in Euclidian quiltpieces.

Sunday a huge weathervane day, mass a chance to be alone with her, incurring the congregation's displeasure and the rector's scolding for lateness.

After lunch at the beach, we climbed high and walked along the customs path (the *sentier des douaniers*) watching a lone swimmer brave the frigid waves out to the *Sept Îsles*. All the gestures and silences and knowing glances, an enormous flat-screen TV flashing thirty-six different ways to knot an Hermès scarf.

Those three freckles just below the left eye lined up in perfect congruency with the predawn stars in Orion's Belt. Millions of magazines were bought by consumers prepared to give sacrifice for that hair texture, its color, its length. When the very faint peach fuzz was detectable above the full honeybee lips, you knew it was beyond close. And a whole alphabet of ways of making the mouth small, to express softness, anger, interest, independence, loss.

There were two dreams, coupled with an immense sense of relief that at least the first one wasn't true. I was tying to talk to you at the tapas bar and you weren't listening. Somehow, channels kept getting connected that didn't need to be, like a cellular call overloading, comprehending other voices. There was this deep, fuzzy painful worry about crossed lines, confused conversations, stroboscopic mixing. The later dream, maybe deeper, maybe REM, had me surreptiously trying to hang a pinstriped suit and nail a map to the inside of your closet.

What came back again and again was the sky—the rapid changes, the dramas played out by the scudding clouds, the showcasing light that said, now look at this, now look at that, now look at me showing you how to look at this, how to look at that

ENCELADUS

When it finally became time to give it up here, the street filled up with the wafting moist warm husks of bran, the elemental pleasure of scooping up and eating a handful of the grains in the middle of it all, biking up the hill at night to come around the corner to the café with the big bowls of coffee mixed with milk; at that hour, there was no astronomical way it could have been a crescent moon that low at that hour in the stormy sky and yet there it was, a perfectly sharp bright white arc that was pointing at something, signifying something, cradling something in its arms filled to the brim with omenicity, the way there sometimes seemed to be a clear progression of signs, of portents, like that afternoon in the car when we saw a rainbow the size of a house splashed all over the clouds, moving through the sky alongside us, astonishing us with its own physical laws, following us and refusing to fade, like some Batman signal in the sky, now having credence in it, its prophecy and augury power, or that time when we could smell the antioxidant oils in the hair follicles of rosemary, it had to have been midsummer owing to the heat, the way the avenues filled up with the light spilling out of the Manhattanhenge cross streets and suffused around the corners, coloring the plate glass windows, the buses, the taxis, we ran from cross street to cross street to locate a perfect alignment, constantly freezing in our tracks because there it was, frozen and full and round, xanthan mixed with magenta, a whole pitcher of Sicilian blood orange juice tasted for the very first time, not knowing then how it was going to light the rainbow we were about to track and later, the moon shadowing us, all those sky-borne magi lining up now, talking about something, semaphoring something, long hours of night giving birth to breakthroughs and surprise, spaces, terraces, parapets, balconies, stairs, ladders telling stories and receiving writing and paint, woven braids, leaf and stems and bark piling up in boxes, experiences that were so here as to be nowhere else before realizing that here was inside ourselves and thus transportable

HYPERION

It kept pouring down upon us in deep sleep, this bright dream of night vision, place names, Samara and Fortaleza, Antofagasta, Bamako, Kwajalein and Kunming like warm towels on the skin, Male, Sao Tome, the fresh water running nonstop to drench us, nourish us, bathe us, mystify and mistify us rolling over in that bed place, whole oceans of currents and waves and foam; straining, attracting, the waters so wanting to reach each other and become one, sea level and gravity, how that one river is the only one on the entire planet that gives forth into two different oceans, drenching the leaves and flora and biodiversity, soaking the ground and swelling the rivulets and streams and tributaries sometimes for days on end, the fish rising and falling until the omnipotent flood carried them over the spillway at high velocity, out into the air to land in the swirling froth below, serving food in the shallows with care and attentiveness and grace, that vertical drop also being used to spin turbines and drive coils and armatures through magnetic fields, generating amperes to operate the locks, locks of your shorn hair floating on the surface as the gates close and the chambers fill to allow ships in, impossibly narrow half-inch tolerances on either side, close to a thousand feet in length, and then the huge mains releasing millions of gallons downstream and equilibrating, the gates easing open and the boat descending gently, stepping down eighty-five feet in measured, barely perceptible increments the way your teachers saw you take stairs when you started school; the lines are loosed, the engines fired, a highway was now there for capturing joy and gladness, abundant blessing, peaceable dwelling, k-sighing, k-purring, k-kittens curling up in your lap knowing now what it must have felt like on the day they first mated the oceans, like joining land to cloud via the slicing drops, each standing vigil over the other as the flame flickered and we wrote it in a book, giving germination for the land to respire, narrow frame for wide angle, the roadway running in parallel with the waterway, diverging and converging the way certain musical passages and phrases keep coming back to you when you asked that flautist to play a few measures of Chaminade's Concertino and while they searched to recall how it went, you whistled it and brought it home again, the slanting raindrops marrying and magnifying everything, green to blue, earth to sky, ships to the wake of the steered lighter, gathering to unfolding

ARIEL

From the air, there were all these mixings and interleavings of sand and sea and reef and somehow also of the waves, reflected sky and the blinding white clouds storing up moisture to let it go later that afternoon, when it couldn't be pent up any longer; there was all this glittering pearl-stringing of islands, spits, coves, cays, caves, on the land and beneath the sparkling salty main, teeming with thronging life and fecundity everywhere giving undulating inundating abundance, the proud colors, the interpenetration of light and shade, the tree branches and root systems, the way they bent and curved and hung under the weight of the ripening riparian mangoes, fleshy, sweet, pulpy, their days and nights of soaking and drinking and taking up sun to be consumed, giving back the tropical torrid, torpid warmth and languor, limpid firmness pressing on the cheeks and teeth and tongue, up against the roof of the mouth; always this pervasive sense and awareness of that clear, deep, fast river, wide and navigable for way more than a hundred miles inland, an alluvial flowing fluvial super-highway of superpositioning, layering upstream on down, all kinds of trees growing to the edge and then, even out into the current; there was this intense desire to dangle from the overhanging branches into the water and connect, collect, close circuits, fruitify, fructify, drink, plunge, swallow, slake, dive, swim, soak, compose music, make scientific discoveries, watch genes curl working in concert to glide, and float, and trace as many words as possible onto the hands of a sleeping blind person, seeing the lushness and all the leafy littering reflection of that buoyant clairvoyant uncovering, the way everything was now opening so inexorably, graciously, referentially, selflessly, generously, totally to you

METIS

Well-beloved, mirthful merry-hearted one, you of all people know how you have to wait for it to build within you and unleash, the rain bursting of its own accord, you could see that it had already started, demarcating a year in a rush, parting the cloud-dimness to reveal each one of the boreal winter stars as bright as a full moon casting shadows ahead, making a lodge for sheltering a tabernacle with a blazing fire in its hearth, a great gathering in the midst of the forest, you could hear the fir trees' branches creaking under the accumulating drifts as we prepared a joyous feast-table with flickering candles, brimming goblets, vessels for sailing to the ends of the earth, and even with such an abundance of snow, the night air was saying that it was only the beginning, a pause before the next several storms, each more powerful than its predecessor, breathing in the stillness, millions of floating hexagonal crystals in our lungs, warming them inside ourselves, and then inclining forward into each other's muffler, there to give and get replenishment, always aware of the stillness, the inwardness-outwardness of our progress, the boughs as ensigns of fullness, knowledge, awareness, season-feeling, the firmament holding within hibernal beginnings the vernal comings with the birds, building nests as the waters would begin to thaw even though they had not yet frozen, they were still a cobalt highway, a chalkstone-flecked mirror-ribbon reflecting the fluttering flakes that rested intact on the surface for a long time and floated downstream like a brave starbearer; they gave off this radiance, everything beginning to coalesce and come together, taking on the appearance of the stars so that it became impossible to distinguish all the twinkling twins from one another and in the cement was laid down a diamond-pavé of ephemeral, evanescent buoyant gemstones, lasting, astral, stellar, sparkling, all this journeying and seeking, this ordaining and rightmaking, some kind of innate, intimate knowledge laid open that people had puzzled over for centuries, mysteries unlocked right and left

THEBE

High daytime, hi daytime, all the exhibits and figures and sculptures, the tears and years of building and stacking, carting and wiring and assembly that also sat here, and were then burned or flatbedded out to occupy plazas and parks, this whole place without even knowing it becoming a sacred resting ground for the ages of this relentless cycle of buildup and teardown, of ideafaction and reification and then remembrance and forgetting, before again exploding in on you as you were far away, changing lanes or switching on a fan for the first hot day of summer and that swiveling, combined with the heat, the molecular motion, and the mechanical motion, putting you right there at that moment in that corner of the whiteness in the blazing afternoon and you had your hand on it, you were cranking it or climbing into it or lying down beside it or scaling it or peering inside it or writing on its empty pages like a flashflood roaring down a Utah valley the exact same way for years, decades, centuries, just like this, all of this watching others with nothing and then being watched by them, the whole process a tree made of hanging twirling pavonian compact discs dancing a pavane in the wind, a sparkling Newtonian prismification, looking for shelter, knowing what it was like to cross the desert by wagon train a hundred years ago or by motorcycle a hundred days ago or bicycle a hundred seconds ago, craving shade, just a patch to pitch your selftent and fuse with the shadow and the supine desert floor recumbent in the same gorgeous glowing gyrating giving gaining saying spot from the night before, or the night before that, or a hundred hours and weeks and months earlier and later, never quitting, never letting go of that sacred heated cauldron calyx cruciform crucible, a TV monitor connected by underground cables to its energy source, some of these people strolling around in feathers, silk, lace, velvet, cardboard, foam, faux-ermine, bubble wrap, Saran Wrap, aluminum foil, or just glitter, many of these strollers and marchers and troubadours having within them pent up scientific and technological and artistic and social and emotional discoveries sure to shock, stun, surprise, ennoble, and pacify the world, their breakthroughs spilling out of the birthday cake in tiers and tears and layers of revelation and dis-concealing thinking that it was impossible to top the previous day and night just as you mounted and crested the hill to see spread before you a vast new plain of possibility and potential and pleasure, a biblical land of milk and honey to explore and settle and draw and worship in, a place to connect and communicate with the divine and to be struck dumb by the majesty and vastness and fastness of her creation, their joint fashioning, a place of sowing and harvesting and storing and consuming, all these feelings and desires driving you toward this heightened reverence and devotional page-turning that upon reflection, maybe you had hoped for, wanted, desired without being able to describe it, but now, this spontaneous combustion seemed to have been foretelling something, foreshadowing and hinting at and pointing toward something, not in a single mind but in more than one, the way you rode the art car whispering, speaking in languages not your own, straining to form the sounds and shape them into words and sentences and paragraphs, so that only much later did you realize how hungry you were, eating shelled pistachios and bananas and dried mangoes, snapping them between your teeth and drinking pints and quarts and gallons of water to get clear, you knew you were headed somewhere, there was a magnet calling you, a loadstone of musical embrace and hugging and melodic counterpoint so simple even as it stripped bare its complexity to show its core, words to spur, to be uttered, much less written out in full, all this was immanent—resident, inherent, innate, in that gilded, argent, ardent painted and blanched plain so much as to blurt it out, to shout it down from the surrounding hills and mountains, you so privileged to see and hear and touch their day, this night, this living, this created being of unfolding and magic, you were going to live in its window for all time, calling to the passersby, watching the pink geraniums let down their cascading Rapunzel hair, you able to make it come

alive again, and astound your own self at your own prodigious output and pouring, you watching these scenes immerse themselves and emerge reversed only to be re-reversed and ready to be formed and made into movieing in all this cinematic casting and directorship, with your special touch and talent and spark and ability to see, you making and measuring with a compass and a sextant, with those flames in the distance, that incredible self-reliance and forging, that alloying of something you noticed in one place yoked to something that caught your eye someplace else, in twin permanently altering the way we see and enter the world—skies, clouds, waves, rivers, rootsystems, branches, trunks, leaves, deserts and savannahs, rocks, boulders, fracture lines and fissures—your cherished planet-world in motion and growth, you filling in line after line of an illuminated manuscript with your careful casting so that we may finally see, pressing the red button to record and zoom and replay and edit, opening yourself up, sewing and stitching the scenes together so we can sail in them, fly in them, float in them, build structures in them, and, then, like that tent, crawl in there to dream of what's coming, what the new day will bring, the key to morning's glory: you're there right now and you know I'm there

ELARA

Ever since you had first been coming here, you'd told me about Fly Hot Springs, named after the airstrip where the pilots from the thirties used to land, and it was always some kind of mystical Mesopotamia that maybe was now mythical and had disappeared, now a dry place and maybe someone far from there was feeling the warm waters shoot up through the vents; the ruggedness of the landscape, the tumbleweed, the ceaseless wind and sun, the scraggly vegetation and growth and the sweeping vistas, the desolation and straining to see the steam and behold the buildup to which there has yet been no denouement, the reds and rusts and ochres, the purples and browns and tans, you wanted to kiss and embrace this place of bubbling, this highway to the center of the earth, the molten magma down there in the core driving the plates and creating the magnetic fields which guide the charged particles and cast them up against the solar wind; here, it's all visible, present, tangible, no one around, the stillness and the silence and that time of day when there is absolutely no sound other than the trickling water and once, the flapping of a heron's wings, and then this coloration, a washing, a limning and lining up of light that can only take place out here on a day like this one, the long trail which winds around to the swimming place, and now it was even more silent, and every once in a while you thought you could hear a voice or two, or imagined it, and then there was nothing, no sound now except the breeze in the tall grasses, and you climbed onto the roof of the truck to take pictures, trying to capture this solitude, this pristine pasture of water and pools and a few lucky trees and that sky, so much sky and horizon, skyfly hotsprings, you snapping away, white and beige covered in aureate gold, speckle and sparkle and the slanting lateday fading rays, still there, holding, cradling, gilding, painting, dusting and frosting you as more and more pink mixed in with the gold, the way you do it, trying it, altering it, adjusting it, modifying it, only out here it was being done, and of all the camera shots, this next one screamed and begged to be seen, there, where the others swam, their clothing in piles and the dock stretching out to the middle a few inches beneath the surface of that warm, comforting, embracing, surrounding water, careful treading on the planks and then being enveloped by it, the water liquid an act and rite of purification and cleansing, this place where the water collected where it had come geysering forth from the earth, just enough distance from its spewplace to cool yet still be warm, a muffin just out of the oven, a baked potato right after you split it open with a fork floating on your back and watching all the yellow metal in the sky slowly become white metal, gold turning into sliver, the Rio Oro flowing into the Rio Plata, sun changing into moon, no one daring say a word, everyone driven inward by the way it was all running together now, the water, the light, the sky temperature affecting the liquid temperature affecting the body temperature, the specialness and isolation and unknown infinity of this pool and the bodies it had held and cupped and contained, now doing with no sound

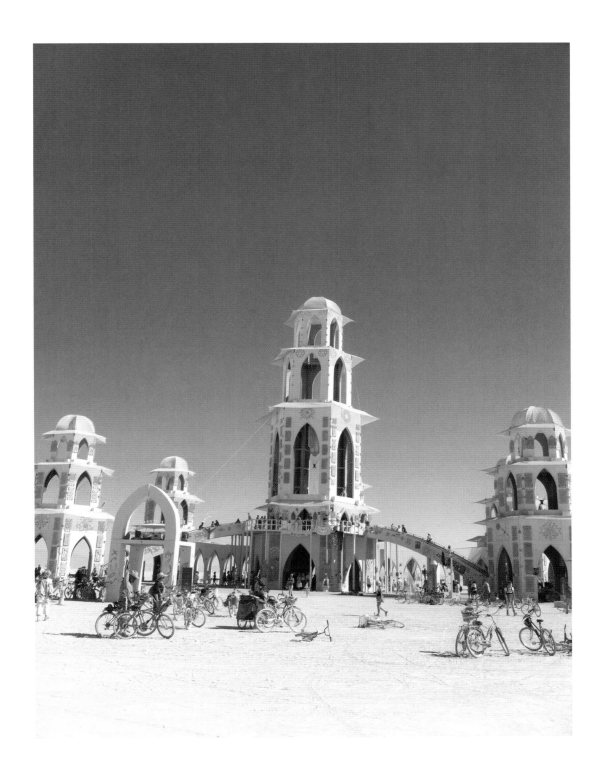

DEIMOS

Trying to describe it was a sizable but not insurmountable challenge, and maybe you needed a certain minimum of time before you could do it justice, reading so many of the others' accounts, looking at the photography books, seeing the movies and videos and all those images on the Web, maybe you needed to construct your own system of streets and names and themes, one thing coming back again and again the experiential elements that you had to actually be there to feel, the molecular code that held it together; the 24/7 music, the many musical genres, the things that happened to your skin, the sun, the cold, the fine white dust, the thousands of small interactions with the other people, neighbors, citizens, pilgrims, travelers, questers, seekers, escapers, actors putting on costume and mask to reveal rather than conceal, the repeated resolves to fix-freeze a given moment and never forget it before it suddenly was overridden by a new image, the fusing of sound, time, distance, like just before midnight standing in the midst of a long row of fire cannons that were repeatedly shooting huge cumulus clouds of orange red flame into the night sky, riot-roiling the air, warming your chest and face as you watched, or the next night, the crescendoing escalation of voltage building up in the tesla coil and sparking and branching and buzzing with someone right in the midst of it, in a firesuit and sword taking the voltage and passing it on, maybe that was what was happening in each of us, this awareness of how each of those highly affecting dramas was signifying something, standing for something, saying something, the screaming whine of the jet engine spewing neon yellow-green fire, the waterfalls of creativity cascading everywhere, from propane-spewing dragons to ten-story climbable bamboo towers to blinking lights high in the sky that were planes, fireworks, balloons, lasers, powerful searchlights of such intensity that you could ride up and across the heavens on them, interstating your very own milky way through the constellations, all of it a giant Rubik fitting daywhite with nightdark, the temples and pagodas and ogival arches of structures giving way to illusion, to interactivity, intricacy mixing with mass and size and scale, that massive toroidal arc of the covenant made of thousands of two-by-three planks nailed together to hold and carry progress, percussion, dancers, all seeking somehow to channel its ingenuity, its lighting, its mind permanence in multiple emulations, whiteouts imitating the cold and snow of the winter months, the blazing pink-stacked Rothko skies of eventide, the supercharged fans in a circle ejecting a spiraling tornado of wind to take the firefighter astronaut's urgent jetties of fuel and set off wave after wave of scorching plasma that warmed the drawn-in pilgrims against the shivering night, glorified their rows in a mute-rendering, boiling torrent of spinning, swirling, soaring, solar radiation that promised to go critical in four billion years of transuranic fusion that was never going to expire, suddenly flaming out in front of us, and only a few yards away, those huge floating flowers suspended high in the sky like cousins of the moon, all the randomness and chaos forcing the mind to make some sort of order, the whole set of experiences something like taking seventy thousand pages to finally prove Poincaré's Conjecture after a hundred years of trying, thinking forever about columns and rows of color, shape, timing, sequence, sparking, surprise, predictability, particle, wave, two years ago, last year, this year a whole spincycle that centuries had laid down, the promise and evanescence and fizzling cinder-embers lighting our way every diamantine twilight that said this can never be surpassed, only to lay the groundwork and raise the bar, to assemble, to hoist, to light by muscle and generator and firegunning fluttering fabric a stairstepping Bach's Canon in D or Jesu, Joy of Man's Desiring

HIMALIA

There were all these analogies, places at great distances that were only travelable through mastering macro, micro, nano, Velcro; what kept coming back was how all this provided you, even when you were well away from it, with the resolution that some kind of larger, grander satisfaction was emanating from the pink-orange of disorient, all around you were unmistakable signs, the ten-thousand-year year waterline marks where the lake had receded, the geological birthmarks, the eternal flatness and all that candor, shadows, no shadows, the midday blistering, blinding heat and warmth trying to understand how to store all the brightness, releasing it little by little when you needed it, the day-neon paired with the nightfish, the seahorses swimming behind the bikes as each scene came to depend crucially on what time of day you had seen it, waking up to bathe in the human car wash, the bristles and buffers burnishing you, readying you for Matisse, Cezanne, Bonnard, the multicolored people, children, grown-ups, animals that you used crayons for on a rainy day and here they were, speaking to you, towering over you, beckoning you; the prayer flags at high noon and your messages of camping together in a theater of dreams, creams, streams, seams, beams, when you returned at 2:00 a.m. and touched the flag with your fingers, you felt your own message charging through space, the sea, massive temperature swings, the fabric flapping and fraying and casting its message out through the ether, daytime recalling that stroboscopic afterimaging, the five-story wooden structure, ultramarine mountains, scampering legs, hairbands and sunglasses shimmying up the trunks, and then, with arms pulling them up to the next level, it was only a matter of time, so many times repeating to yourself, who thought of this one, what we gave away and received, the plastic cards splashed in gold, turquoise, aqua, fuchsia with stars and stickers relentlessly saying "this is the only day that has ever been given to you in all of human recorded history, make it up yourself, make the most of it, and do the same with its starry, lunar twin," taking note of all the other things, the flock of giraffes, the shade, the coffee, the ice, the hats, the sunblock, the whirlers and hulahoopers and singers and comedians and rougers and fortune-tellers where someone could ask you if you'd like to have your stomach painted yellow, green, pink and you said yes, all your years on the playa swirling together in hourglassing sharpness, the continents and currents and aquatic life diving beneath the surface to come up face-to-face with this sparkling, shimmering peak of day, afterday, blinking your eyes to rest from all its luminous fireball intensity and in that split second before you opened them again you were in that other place that you knew you would leave the moment you unblinked, but in that transient, transitory, transalpine, transoceanic, transforming, transcendental fingersong there you were, dancing in the front row of the crowd being stoked to motionfury by the gunner straddling that enormous cannon, squeezing the trigger to send boiling fury at an angle fifteen feet out in front of her to frenzify the people, wondering what to call her, what name to give her, maybe cannonière, the scarlet scalding petroliquid fuselit firing round after round calling to mind fierce, ferocious, savage, truculent armed conflict, artillery decorating the pitchblack sky with curled tracergushing torrents of hell trying to fend off and nullify the incoming hailstones of shellrockets and missiles and technocondors trying to wipe you off the face of the earth, the look in the ravers' eyes saying that that videogame had already flickered through their minds, riding the irresistible addictive music playing in the frontbeat, here everywhere concelebration, juicy running rivulets of molten lava spilling up the night slopes to mark the whole northwesterly-tracking chain of Hawaii's necklace splayed across across the vast blackboard of the Pacifidark parchment steppingstoned with staccato stupefying fireflame hot enough to sublimate metal and melt granite; you opened your eyes

to four nested cubes, each gyroscopically swivelable and spinnable and rotatable on its own local axis while the whole thing could spin in increasingly large articulated frames of reference, sufficient to make you realize that you were seeing into the heart of the Lorentz transformation, here was scientific insight and achievement in front of you, James Clerk Maxwell and then Einstein standing on Michael Faraday's shoulders, within its shiny limbs powerful secrets straining to unleash themselves into energy generation, biology, genomics, robotics, particle physics, the way these shapes could be set in motion and still reach you, when you were lying down looking up through the flashing synchronized lights of the swirling carousel cubatron, the shades and hues enchanting and entrancing you with one color all at once, then another, then yet another, and then, fast swirling, fast twirling, making your synapses race to match them in first this pattern, and then that: sinuous, undulating, flickering, flicking flecks in crashing surfs of aubergine and rose and apple and marshmallow seen in plan, in perspective, in isometric: tomatoes, lemons, limes, grapes, Ping-Pong balls, raindrops and fountains and fire hydrants marking and making space, merry-go-rounding in one direction then the other, the eye feasting on hardware figureskating with software, none of this conceivable before the light-emitting diode and the microprocessor, this whole Thanksgiving Day parade a spectacular glowing display of majorettes wearing their best high school band uniforms before click and hard on their heels another one, us lying beneath the surface of this translucent street all hypnotized and staring upward in gaping gasping wonder

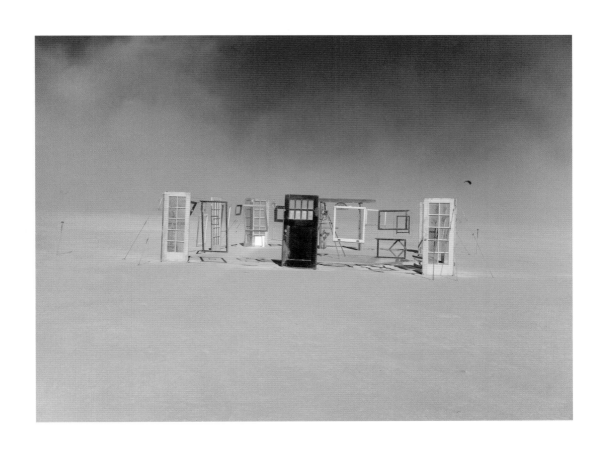

ATLAS

And now sleeping, talking, sleeplessly longing, dreaming, waking, dreaming again in unending sequence, trying to process the day and night and the previous day, surrendering to all the things you saw and experienced, being absorbed by them, streaming and rising and biting your own clothes or clenching the air, full of courageous heartful dancing and shouting, and singing and swaying in music-sweetness, sweatness, richness, togetherness, intoxicated composure, drifting in and out of wakefulness, dreaming, doubling the days up to medieval winter, trying to make sense of this spinning, swirling carnival, the praying and veiling, the unveiling and revealing, the people you encountered, this luring, this transforming, this shaping and reshaping, the creating and conceiving, building what would we be without generators, el-wire, LEDs, neon, gardens and pathways of color, flowing streams, flowers, nightingales, teardrops dripping from your eyelashes, nightplanes still landing at 4:00 a.m., flying low into every tent, running across the playa only to be captured, drinking water to slake the day's thirst as we drifted, rhythmic breathing and tiredness and sleep deprivation not needing earplugs, our harmonious, shared, peaceful place levitating to greet us, floating, stacking blocks of Lego, posing for group portraits, fighting sleep every step of the way, needing it desperately, wanting more than a few hours, revved up high and being totally unable to slow it down and switch it off, the music just as loud now and coming from multiple sources, then fainter and more muffled, something drawing you off, being begged by sleepfulness to give it up at this point, grab anything, a nap, a snooze, forty winks, something beckoning, flirting, whispering, winking, eyes three-quarters shut, talking to yourself, not making any sense, not making this up

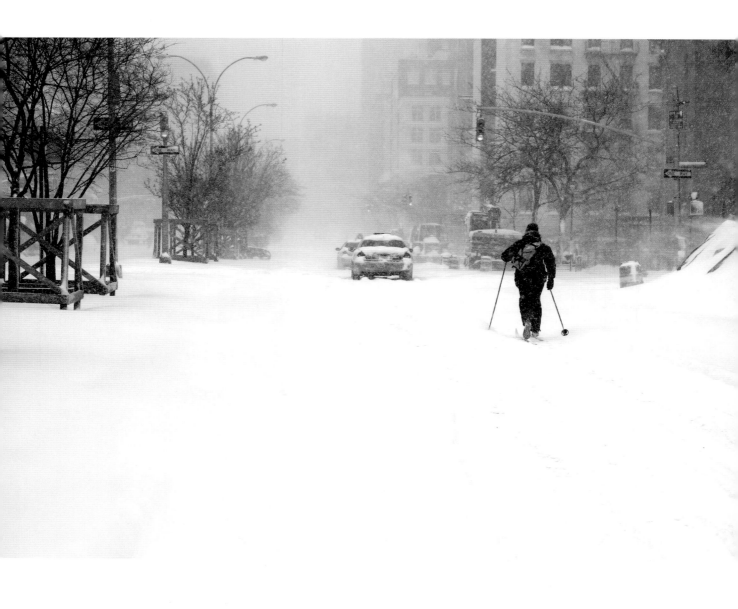

Io

Times when you were sure what was going on. You found yourself everywhere, trying yourself, knowing and treating yourself, meeting and believing that somewhere there could be a you whom you could release yourself into, exchange yourself with, and line up your cesium clock to the same second with M.C. and Joan Armatrading in full voice.

You made you that way, about teleological things, preparing yourself. It had an abandonment, a clearing out, a cleansing, a right rite of purification, an ulterior DNA that itself dipped down through layer after layer of code. There were portents: the far shore, your eye-genre, exponents, the way Düsseldorf appeared nice out of nowhere, after such a long absence, in the daywake. The story was cascading in and converging toward something, charging in the direction of a construct that would not quit.

Letters, script you'd never read before, from a six-thousand-year-old city. You wanted its best shot, bigger and swollen beyond imagining.

The detail, the abruptness, the cinematic cuts in sentences and paragraphs, the randomness hinting at pattern. And then, the shocking, powerful reuse of imagery, constantly cutting back, curving in. How useless cars and all sorts of tools were in the face of it, the need for rivers and coastal lighters. Maybe here you finally found the you you were searching, you found your match. The computer shutdowns, the moon, the trees, the icicles, the underlit clouds, the warming, the emptiness, the science fiction and history, the gnomonic representations of selves. The new worlds built up on top of the surface, somehow also exposing and nudifying the real worlds.

Where did you get all this, the detachment, the continuation, the finishing, the closure?

You pressed your face up against the glass, and it pumped up your insides to bursting. It had not yet happened, the fullness, the exhaustion, the wanting it to repeat at the same intensity, if not bigger. It was an emotional roller coaster. You were getting addicted to the high of starting a new cycle. You couldn't wait to start another and experience it, the hope that this time it would work.

How time began to slow down and recede, like an oft-repeated, never-recounted childhood dream, replete with banners and gonfalons and fountains, blooming purple loosestrife, cobblestone streets leading up the hill from the port. What kind of dream—from three nights earlier—you weren't sure why. It was like the book you were reading, being able to re-create all of it, down to specific punctuation and even where the paragraphs were on the pages. It was macros and numbers jacking in, measurements of vertical potential and units of work, foot-pounds and dynamic joules.

Everything was unmade and remade. Satellite images, voicemail, cellular, beepers, fax, caller ID, digitalization, Facebook, Twitter, YouTube, they all pushed you out into its eye, into its vertical ventral vertigo, to feel cold. You now knew what six hundred inches of snow really meant for Sakhalin Island and Hokkaido.

It was the guitarist, it was Souen, it was hear here her you. Seaweed with the light and mist and the parting curtain of the water condensate on the window.

This was the storm you wished for in all the height of its howling, you wanted it even stronger and longer, everything suspended and indefinite. And then the railroad, speeding speedsteel on Peter Cooper's flange.

Top of my list, wanting to call.

Cowboys 38–27

Paaliaq

A quintessential experience is landing at O'Hare in the dark, with the crisscrossing graph paper gridlines of tangerine streetlights marching in precision all the way to the horizon, thin dotted runways running everywhere. You start probing the reasons why this place always sets off these thoughts and this river of consciousness, the lake, that lake, everywhere the lake: its size, its overpowering dreamshare of the residents' waking and sleeping minds; maybe it even had some kind of huge chromosomal defining quality with its effect on the microclimate, its rapidly shifting colors, its slowly shifting temperatures; what that means, the lack of riverine borders between neighborhoods and boroughs, the lack of a central borough like Manhattan, the lack of a defining island surrounded by a Hudson, a Harlem, an East; how life gets approached here, how little transactions (buying newspapers, picking up dry cleaning) and the big transactions (courting, romance) are processed differently here; maybe due in part to the architecture, the architects: the Tribune Tower, the Hancock and Amoco Towers, the Wrigley Building, 900 North Lake Shore Drive, 333 Wacker, Marina City, Carson Pirie Scott, Robie House, the Columbian Exposition, Daniel Burnham, Louis Sullivan, Frank Lloyd somehow a Pink Floyd, all over the drafting tables en charrette; the population, the pride, the conclave of ethnic enclaves, sky and cloud somehow here in not a starring, but instead a supporting role; things constantly playing out on a big stage with this place as fulcrum in the evolution of motion and transportation—first, water; then, rail; then, the automobile; then, air; the weather, its inevitability, its strength, the residents' strength in meeting it face on, their anticipation of it, their pride in knowing others couldn't take it, others can't believe that these people every winter confront it and prevail, year after year; the history of the place so bound up with those of the state and the nation; the arrival and departure of growers, who emigrate and then send crops back; everyone knows the shore of that Mediterranean to the east, only a few realizing that they also look out upon a terrestrial Atlantic to the west, the mental overhang of the states forming a Rand-McNally in the mind; the relentless white noise brain-positioning of Wisconsin, Michigan, Indiana, Downstate, and then, Neb-Iowa, and Kan-Iowa, and Minn-Iowa, and Ohiowa spiraling in and encroaching from the verges; big, tight families full of siblings who so love each other that they constantly nickname one another after suburbs: Morton Grove, Winnetka, Kenilworth, Glencoe, Wilmette; looking for the deep channels of enzyme connectivity, between the passion for sports teams, the different kinds of food, the relished love of eating, that faster pace and the lung-screaming jackets and badges, badges and jackets, futures and options, local networks irrevocably connected through global screens and terminals to hand signals and a hundred-year-ago farmer's tentative, halting decision to hedge

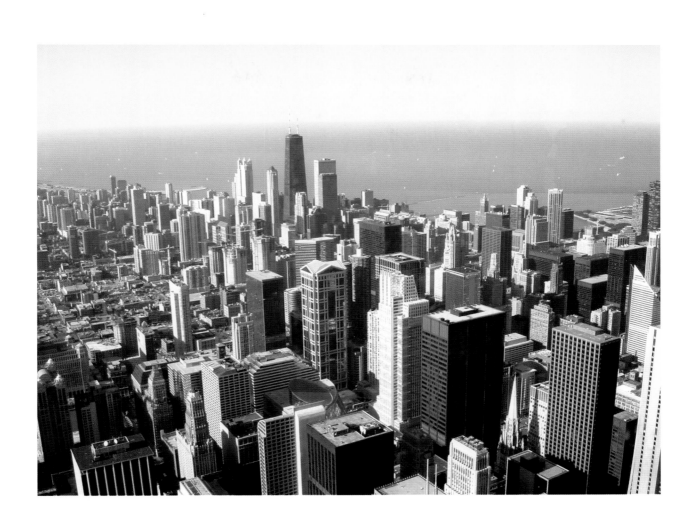

Pasiphaë

One thing, many things she said that never stopped vibrating and resonating within you, never left you, would not release you or let go of you was the way the food and drink were laid out on the ground, on the grass, on the soft little fluttering picnic cloth, the homesteading of these little plots, such eager expectation like that brief pause between two tracks on a CD when you've loved and repeatedly played the earlier song and so far all you have to go on about the next is the title, and the digital number appears in the play window, and the first few seconds tell you you're going to fall head over heels for the new song, unmistakably created from the same mind and instruments, yet so commanding in its own character that your hair stands on end, your hands tremble, you well up with wave after wave of self-recognition and discovery, sublimity, bliss, marveling, becoming; that ground, that field, those slopes, sitting there and tangibly, palpably sensing your feelings pulsing through street after street to ripen into plum, apricot, fig, cherry, summer's sailing, anchoring, the fleeting hours making us ships in the sea, planes in the air, birds building nests today to huddle together in later for warmth, for nourishment; that deep part of you that's sacred, defining, ineffable; knapsacks with cheese and a cutting board, the tree that they had planted in memory of their child and chosen that one morning to come back to and pray for and revere, in the bright sunshine, the shiny greenness, the faint-stirring breeze, the communal, obvious explicit shared enjoyment by so many of the day and the space, maybe they were saying that we, like Isaiah and Jeremiah, were called even before we had come into the world, that here the relationship between art and life takes form in a sleep in which we cloister ourselves off to study and contemplate, only to awake in the dream to intense illumination, vegetation, the wispy fog opening up to reveal and disclose broad expanses of dawn fanning out below all the way down to the sea

PAN

Maybe it was the balmy temperature, the breezes, the lights on the vessels, the whispering voices of the strolling couples, the grass, the Andromeda, the fresh maple leaves, maybe it was where we had been sitting, with that open room to the sky, and the aquarium, and the wood and the headphones, because out there, on the riverbank, you could feel the earth breathe a sigh of relief that the heat was manageable over here, the motion, the quiet, the calm, the softness, the care, the permanence and reliability and strong bondingness of the shore, how all these feelings built up to a musical phrasing that after that day's unfolding had been bringing you there, bringing you to that point of closeness and communion and conjoining, you shut your eyes and it was valleys and swales and a voice in your head describing the sunrays, the people walking, their out-of-doors ways of connecting, sea bells and buoys helping you to navigate and anchor, you mixed in with these ethereal sensations, twilight, finding your way, halflight and vagueness and that lapping and splashing water trickling down a brook, bringing so many places to a mutual there, pictures and photographs, paintings and drawings, models and maquettes and sculptures, all bringing sleighs of learning, vitrines displaying village scenes with the whole world in them, reflecting, evaluating, praying for insight, wisdom, guidance, judgment, those waves bore us up and bore us on, a standing, frothing, churning singularity that made its way up every river that spewed its fresh freight into brine, flowing sparklers hoisted aloft to light our way, mighty nutrient sources, swirling eddies that curlicued and fluttered in white feathery gossamerness, climbing the cascading waterladders to bathe, drink, ladle, cradle, purr, curl, turning to look at the ships' railings fashioned of teak and teal and tears just at the edge, iron and blue light, shiny and reflective in that air calling attention to itself, to that turning, that drifting, that sinuous curving cozy saucering to the point where it never left you, never once took your respectful leave, kept on holding you, whispering to you, candlelighting you to sleep, reading to you, reciting your name every night, returning home to glide with the engines off, the forblades still rotating, unable to let go, coming back round to the beginning

GANYMEDE

Maybe it goes something like this: if Japan were in Europe, it would be Germany, and if it were in the U.S., it would be Minnesota; if Singapore were in Europe, it would be Switzerland, and if it were in the U.S., it would be Iowa; if Vietnam were in Europe, it would be Romania, and if it were in the U.S., it would be Louisiana; and if Hong Kong were in Europe, it would be Spain, and if it were in the U.S., it would be California.

One of the most exciting and unforgettable things about Hong Kong in those days was landing there, especially at night, at Kai Tak Airport, then rated by pilots as the most dangerous airport in the world. There were incredible aerial maneuvers that had to be executed to make it happen, all within extremely tight tolerances due to the proximity to the runway, amazingly close, breathtakingly close, of hundreds of apartment blocks. It was dizzying, surprising, giddying, frightening; you could see what these folks were watching on their TV sets. They surely must have seen the airplane passengers' faces, pressed up against the portholes. From July through September, Hong Kong gets drenched with torrential rainfall. Last year, it rained for ninety-one straight days, and on some of those days, it rained nonstop, and on some of the nonstop days, it rained horizontally, making it difficult to imagine landing an Airbus 380 in such weather.

On days when it rained hard, you could watch the rain drench the leaves and plants, the visibility plunging down to zero, and then, after awhile, the flow of water off the sides of the hills would build to deafening volume. This place was always a city of such contrasts: between rich and poor; between old and new, nowhere more evident than in the architecture, from colonial verandahs to the Bank of China building and the HSBC headquarters. The architects favor atria, and waterfalls, and fountains, often in combination with one another, to shape and channel water inside the gleaming plazas and buildings, the dramatic settings and sounds produced by the cascading water managing to bring the outdoors indoors.

Everywhere, even in the air, you were constantly aware of the vast Pacific, nourisher and energy transporter of the planet. Of the earth's 200 million square miles in surface area, the Pacific covers over 60 million, two Atlantics. Being pushed up against a giant body of water like that, as China and Hong Kong and Vietnam are, or being sprinkled through its waves and currents, as the Philippines and Indonesia and Papua New Guinea are, not to mention the island nations of the South Pacific, deeply affects the weather of its inhabitants' minds, in the working out of spatial relationships, in their maps, their history, their trade, their communication. The Pacific has now been shrunk down yet another size like a hand-me-down shirt, first by the stellar-driven outriggers, then by the sailing ships, then the clipper ships, the steamship, the telegraph, the telephone, successive generations of airplanes, faxes, voicemail, global television, and now, the mobile Internet. The Pacific coasts of China and Japan and Australia are now where Hawaii is. The Pacific is now an Atlantic, and the Atlantic, a Mediterranean. The mind has had difficulty coping, because the mental distances have been so reduced, but the passage of the sun, and the physical reach of the ocean, with its conveyor belts of heat and weather and El Niños, have all stayed the same.

These thoughts flood into you on that long, exploring run in Hong Kong, that hot, steamy, humid, muggy trek that makes you sweat and struggle to purchase those staggering views. You climb first

from Central, weaving between row after row of gleaming new buildings whose forms, colors, and materials amaze and delight; you don't realize that you're out of breath until you're well up Justice Road, and the heat and your perspiring heart hit you all at once, and you're thankful to have drunk plenty of water and made it already to Bowen Road, which is quite high, but still only at what are called Mid-Levels. That gives you time to set up the drama in your mind and glimpse what it will look like in the end. You feel like you've dashed up the inside stairs to the top of the tallest apartment tower in the world, but there's still so much mountain above you. People above Bowen Road know these views, the marine breezes, the flatness. Those epic vistas leave you stammering for the right words while your heart pounds and your pulse blows the Ironman off your wrist.

Leaving Bowen Road, you ascend again, very steeply, up Wan Chai Gap Road. It is a monster, with no quarter given for stopping or slowing to a walk. It climbs, and climbs, and keeps on climbing, with the water roaring down past you, past the slippery guardrail in your left hand as you finally reach and cross Stubbs Road, onto Black's Link, itself a tough, steep climb, but nothing after the vertical ladder up the side of the world that was Wan Chai Gap. And then, Black's Link begins to tantalize you, to offer and yield up these supernatural views of the Pacific side of Hong Kong Island, not the Kowloon and China side. Over here, you feel grateful, you feel let in on a secret, seeing the bays and sailing boats below you, the clouds, looking towards California and thinking about what time it is in San Francisco if it is still a sunhigh 6:00 p.m. in Hong Kong. That makes it 3:00 a.m. in coastal California, their sleepers dreaming about full moons lighting the sky. Again and again, you are struck by the expanse of forest, the trees, the eagles wheeling and turning below and beside and above you, riding thermal updrafts like the springy branches of a spruce.

You run on, headed downward for awhile, and you feel this jubilation and happiness, like hearing a song that you've missed and desperately wanted to hear again and you didn't even know how terribly you've missed it until you heard it, again that one time that sealed its fate for you, that etched all its lines into your photoresist solution and fused its sounds forever into your own circuitry, moving it from the web to your own hard drive. All that cherishing, all that optimism, all that rising began to spill over, because you knew that even though there was another hard stretch ahead to reach the top, you had broken the back of the tough part, you had endured heartbreak and notrightness and hurt and pain and you had made it through, toughened and fortified in the process. There was a feverish, nothing-can-hurt-me-now aspect to it; if you could take this and live through it, this immense internal pain, the next part, the next pain, would be nothing, and then you would be there, you would have achieved your end, your omega, your goal.

Passing deep reservoirs of sky on your right, you begin the long final struggle to where it is that you wanted to get to for so long. You bound up stairsteps in the final stages, you are moving quickly, you are within striking distance, you fixated on its scent. You crest the toppermost point of Hong Kong Island, Jardine's Lookout, the place you had worked so hard to attain and that was worth every moment, your accelerating heart-systems catching up to you like a Mach 3 shockwave as you stood in awe before all that lay exposed before you, the pounding sound of your heart racing onward like Olympic storms swiftly closing in on you with lightning-swords of Damascene steel. You owned these commanding views of both sides of the Island now, the Pacific side joined to the Hong Kong harbor side, you were entering China, and Kowloon, with its extreme building density, all that human energy and striving and exertion.

You were washed over with the breath of her breezes, you were so joined and connected and made whole and one. The fragrant harbor sits there before you, and you are astounded by the enormous number of ships lying there at anchor, waiting, that can be seen from up here, but which remain unseen and outside your view when you are down below. There is all that pent-up force, and attraction, and drive, and you, up here, are confronted face-on with its power and scale and meaning. You want this moment never to end, like the built-up fires still blazing and the soaring, leaping coronas, showing you views of that solar furnace that you'd suspected and hoped for but never let yourself think about directly for a moment, and the point was, that Hong Kong, the sun, the world, were wanting you as much as you wanted them, the harbor, that fragrant harbor, that vantage point, the curves, the shining leaves, the footsteps to get finally to here, and then to link here to everywhere else, here to your life, here to your love and nature, here holding up a mirror, here revealing and disclosing frank you, here never leaving here, even as you find yourself already charting and planning the high plane and peak and point of here, the next eclipse

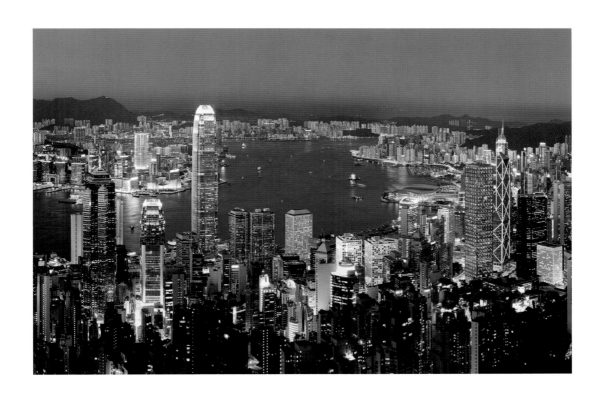

CARME

Because of the force and positioning of the Gulf Stream that day, our route was like no other ever flown, so high, so northerly as to be almost technically impossible, out of the reach of radar for hours, and then suddenly, the mountains, the snow, the glaciers, the clouds and later, the Canadian coastline jutting blue into the icy silverhalide waters off Labrador, fjords and unnamed rivers, uncharted islands and mountains and shore all mixing together, in the dream you were with me there just as vividly as you had been with me a second earlier, before I had drifted off, right next to me driving, near me with you at the wheel, close, bright sun and maculated shadow, clouds, rivers, lakes, fields, forests of your upbringing, you raised them and they in turn sheltered, harbored, inspired, incited you to do things that were different that much of the time you didn't even know how different they were, deciding to draw up nature's well-bucket and ladle out long cool draughts to drink, it now making such sense, how those formative days connected to Fenimore Cooper and the O'Keeffe sisters, to James Agee and Walker Evans, to the nitrogen-oxygen interchange and the reality that we sleep under the open sky every time you shut your eyes, even under roof, this connectivity with the four elements and the four corners, this open, wide-eyed, wondrous curiosity about the world, seeing mirrors everywhere, in the raindrops dripping off the end of a leaf, on the bouncy-branches of a linden, in the inestimable alignment of the Milky Way reflecting waters pouring their freshness far downstream into the salt.

Passing up and down those streets and lanes and wood-paths, feeling the heat waves, the snowstorms, the first running sap, the trees in peak color, shaking the light green spring dusting from our sleeves, we walked, and ran, and skipped, and biked in a world of superlunary waxing and waning filled with reinscription, taking the world, the planets, the sea and all that is in them, speaking in prophecies and tongues, looking for your oneday person in the electric air, the riverine fractal branching of lightning bolts, all the pentimentoed undertakings of growth, somehow, your own dreams nakedly visible there in the valleys and intersections, draped like bunting from the porches of an inn, in my dreams one way or another the twin dreams totally interwoven, intertwined, intermeshed, two crisscrossing streams, three strands of braided hair, a nightly playing out of this playa-pungency in tangency with now, beating as in one's own heart, some kind of sacramental joining that with each passing day and season was managing to become tighter, indissolubly entangled, a perfect fitting that had this algebraic balance and equivalency, so that when one felt something, so did the other, at the exact same time no matter the distance, in the dream and in real life like the physics-experiment particles on opposite sides of the CERN raceway under Geneva, when the spin of one particle was flipped from top to bottom, the other was meticulously measured and shown to have done the same in unflinching tandem, rising like a new star in the sky, or climbing the rigging of a wandering bark crossing the equator, when one was doing it, so was the other, action at a distance, all this joy and melancholy in a cup, phrases of Bach music coming back, the pumpkins almost touching the bending boughs of the sycamore trees flanking the road.

It reappeared, this discovery, the crowding, the hours, the streets, classrooms, houses of worship, relatives, were all one big server featuring thousands of hits every day, this unmistakable feeling in the dream, of someone taking there away from there whenever they went away, to a new living town, and thence to another, and still yet another, once in a while bringing them back, you wanted to remember everything but very few things had been able to capture you, every conversation was

an unfolding, and in some jammed, re-edited way, was getting reinserted into the dream, and then taped right over the top of those other feelings, they were incredibly serene, how this constant filing and building, leaning out a window, advancing through noon and night, driven inward, onward, up-ward, re-creating some sort of recombinant DNA, seeing the ways the streets meet one another and how the houses face up to and greet the road, the neighboring hamlets, taking them in, integrating, pulling them to make new being, new space, new self, new breathing, trickling, joining, gathering, merging, rushing, remerging, conflowing, confluencing in eddies and Coriolis-currents, it was here that blazing insight sprang forth about how it all works; trying my best to come to terms with the dream, to fashion a narrative that could hold together and make sense, some idea of all the places you could go to, ponds under the leafy shade with cloud reflections making formations in the depths, calling to you, whispering, the light shipping and skipping, heatness going out of the day, thoughts as you began to hover over this huge relational map of your own making, visual experience of a physical world made beyond words, piercing evocations of eternity, immutable evanescence, white butterflies floating among the sweet purple buddleia

Charon

The way the house just stood there on the corner, under the spreading branches of the big-trunked giants that had sheltered it, matured with it; the organized, orthogonal layout of the streets and the neighborhood so willing and earnestly able to soak up the rainwater, the Halloweens, the in-migrations and newspapers flung up onto the porches, that defining big wide veranda that funneled in emotions and belongings and yearning, growth and advancement, laughter and tears merging the way the nearby confluence of rivers was the whole reason and justification and economic underpinning of the town's existence; the leaves, the light, the structure, the yard, climbing up the steps and knocking and you answering, your presence and aura and spirit in there, your dreams and visions some kind of angelic messengers hovering about, your sleeping and waketime, your creating, heroism, ingenuity, loyalty, connectedness, belonging, the vividness of it all, sourcing, questioning, questing, breathing and sighing from the windows and the roof and out into the intersection to blurt out recognition that before we were formed in the womb there was love and before we were born there was consecration interwoven with time, you here in this dwelling wondering without forming the words whether you would someday see a bow in the clouds on a rainy day, you with this deep everlasting self-possession, you gaining untrammeled entry into the innermost heart of your twin who came here to find you, to place spirit in this place with you, you here on your own soil, on the heights, beside the way, at that crossroads so palpable, so influencing, so permeating as to defy and confound description, one little bed, one room, one shelter pulling everything else up around itself like blankets for warmth and closeness, this settlement with its history and family lineage and its drawing near, bicycles bringing back the other quadrants at night, bridgespans and squares quilting up a country full of projection into what it was like, must have been like, is like, will be like, never leaving nor failing to return nor forgetting

THELXINOE

From that dusk of first rising, you sensed it, but couldn't see it. You couldn't see it because the lights weren't visible, and it occurred to you later that because the lights in those towers were always on, on each of these dark solstice days, the lights should have been visible in the darkness, and in fact they weren't.

The fog and mist, that Ides of January fog was not lifting as the day went on, but rather lowering and lowering, blocking out first the night lights and now, even the day lights, which brought you full circle to where you were pondering the absence of those morning lights going all pale in the twilight dawning.

It was enormous, fluffy, thick fog, enveloping, cowling, whitening, bleaching, blanching fog. Windsock fog. With the World Trade Center as two thermometers, at 7:00 a.m. you couldn't see above the 25-degree mark; at 8:00, 15 degrees; and by 10:00, it was all the way down to zero. Snowing, raining, meteorological milkshake fog. Duvet fog covering pillowsham fog.

Nothing was flying but mists, swirls, cold plasma, blanketing clouds. Particles in Brownian motion.

It enveloped you in coziness, quietude, old-fashionedness, connectedness to all the other foggy days here, in London, in Newfoundland and Golden Gate Park in San Francisco, and Hull, and on European heaths, wherever cold met warm, cold land and warm air, cold air and warm land, cold currents coming up against warm ones, warm mixing with cold.

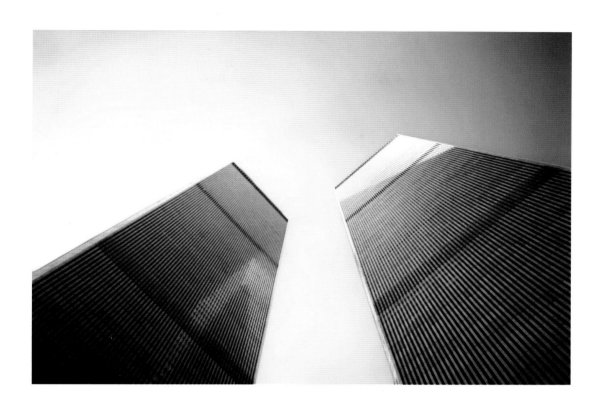